EAKINS
WATERCOLORS

EAKINS WATERCOLORS

by Donelson F. Hoopes

WATSON-GUPTILL PUBLICATIONS/NEW YORK

First published in 1971 in New York by Watson-Guptill Publications,
a division of Billboard Publications, Inc.,
165 West 46 Street, New York, N.Y.

Manufactured in Japan
ISBN 0-8230-1590-4
Library of Congress Catalog Card Number: 78-152785

Although his chief means of expression was painting, Eakins essayed many other techniques, including sculpture, photography (as an investigative tool for his studies of animal locomotion), and watercolor. The present volume is a record of the small, but intensely interesting facet of his work in watercolor, and contains illustrations of all of the known examples save one —a miniature portrait of his father made about 1870, which is not reproduced here for technical reasons. As many as half a dozen more watercolors may yet exist, but their whereabouts are unknown. In recent years, two examples have been located which were known, but presumed lost. A third, *The Pathetic Song*, related to the painting of the same title in The Corcoran Gallery of Art, was not even recorded until the Eakins retrospective exhibition at The Whitney Museum of American Art in 1970.

All of these discoveries, as well as the original pioneering study of Thomas Eakins which appeared in 1933, are the work of Lloyd Goodrich, Advisory Director of The Whitney Museum of American Art. Mr. Goodrich will shortly publish a revised edition of his biography of Eakins, the result of many years' diligent effort. While I have relied securely on Mr. Goodrich's chronicle of the life of Thomas Eakins—which anyone may, who has access to a copy of that now-scarce 1933 edition— I am personally and profoundly grateful to him for permitting me to consult his notes on the artist's works. Without his generous cooperation, the present effort—which is offered as a footnote to Eakins' prolific career—might have been incomplete.

To Donald Holden, Editorial Director of Watson-Guptill, who has responded to my appeals for additional time with a magnificent tolerance and compassion, I am grateful beyond measure. And to his Associate Editor, Margit Malmstrom, on whom the responsibility lies for coaxing this text out of the author's reluctant hands, no words are adequate to express the extent of my appreciation for her understanding and forbearance. But most of all, I wish to thank them for availing me of their time and skills—Mr. Holden in the inception and planning of this book, and Miss Malmstrom in the care and diligence with which she assembled the vital illustrative material and marshalled the many details connected with the project.

Once again, I am indebted to Geoffrey Clements for his superlative photography on the majority of the watercolors reproduced in this book. And my thanks, too, for the excellent work of the staff photographers who provided the color transparencies of works in the museum collections.

My thanks also go to the staffs of these museums, who made available photographic materials for the book: The Art Institute of Chicago; Art Museum of Princeton University; The Baltimore Museum of Art; The Corcoran Gallery of Art; The Brooklyn Museum; The Hyde Collection; Museum of Fine Arts of Boston; Museum of Art of The Rhode Island School of Design; The Metropolitan Museum of Art; The Philadelphia Museum of Art; Randolph-Macon Woman's College; Wichita Art Museum; and Yale University Art Gallery. I am especially obliged to the individual collectors who so graciously consented to have their works photographed and included in this volume: Mr. and Mrs. Paul Mellon; Mr. and Mrs. Elmer E. Pratt; Mr. and Mrs. C. Humbert Tinsman. Additional valuable assistance was given me by Mrs. Thomas B. Malarkey; Miss Beverly Carter, Secretary, Paul Mellon Collection; and Mr. Stuart P. Feld, Director, American Division of Hirschl and Adler Galleries, New York.

D. F. H.

American art in 1870 was dominated by the grandiose romanticism of the Hudson River School and the nostalgic sentiment of the native genre school. Into this art world, Thomas Eakins and his older contemporary, Winslow Homer, brought a new note—naturalism. Like the young generation in Europe, they looked at the life around them and painted what they saw, disregarding traditional styles. Eakins, spending almost his entire life in his native Philadelphia, built his art out of its everyday realities: men and women, their work and recreations, their existence as individual human beings. Few artists have been such complete realists; every figure was a portrait, every scene an actual one.

Eakins was an unusual combination of the artist and the scientist: an anatomist, a mathematician, a photographer, a student of perspective and visual phenomena, and the foremost teacher of his time. His work combined thorough knowledge of nature's forms and movement, an intense emotional attachment to the world in which he lived, and the deep sensuousness that is the basis of all vital art. Within naturalistic limits, his painting possessed the strongest architectonic and plastic qualities of any American of his period.

Among the less familiar aspects of Eakins' art are his watercolors. We usually associate his name with the solidity and weight of his oil paintings. His watercolors, while equally characteristic, show a different side of his artistic personality. Though far fewer in numbers than his oils, they are completely realized works of art in every respect.

Soon after his return in 1870 from his three and a half years of study in Europe, Eakins began to use watercolor. Most of his twenty-six works in the medium were painted in the ten years from 1873 to 1882. In subject matter, they paralleled his oils of these years. There were scenes of the outdoor sports and activities that he himself enjoyed: rowing on the Schuylkill River,

sailing on the Delaware, hunting in the Cohansey marshes in southern New Jersey. There were the shad fisheries at Gloucester, across the Delaware. There were indoor genre subjects picturing his family, friends, and pupils. In the late 1870's appeared a series of watercolors of women in old-fashioned dresses, sewing, knitting, and working at spinning wheels. This unexpected development on the part of the most drastic of American realists was doubtless a result of the historic Centennial Exhibition of 1876 in Philadelphia, which had aroused general interest in everything Colonial and early American. These reminiscences of the past reveal a grave, intimate poetry, without any loss of the utter authenticity of his contemporary subjects.

Eakins' watercolors were far from the spontaneous, direct-from-nature works usual in the medium. They were as thoughtfully planned as his oils. As with the latter, the three-dimensional structure of the picture was often worked out in preliminary perspective drawings, such as the one for *John Biglin in a Single Scull*—drawings that have a precise beauty of their own. But though Eakins was a strong draftsman, strangely enough he made few drawings aside from his perspective studies. Instead, oil sketches in full color were painted directly from the subject, then squared off, and their forms transferred to the final surface. Even for his watercolors, his studies were in oil—a curious reversal of the usual procedure. (Winslow Homer, for example, often used his watercolors as source material for his oils.)

By these unorthodox methods, Eakins produced watercolors that were as finely designed and fully realized as any of his oils, and as complete works of art, allowing for differences in scale and complexity. The physical nature of the medium, of course, did not make possible the full substance and weightiness of oil; but in compensation, there were greater refinement and subtlety,

and a higher, clearer range of color, thanks to the translucency of the water medium, with the white paper showing through.

Eakins himself evidently considered his watercolors equal to his oils; in the 1870's and early 1880's, he exhibited them extensively, not only in the annual shows of the American Society of Painters in Water Colors, but in other national exhibitions; and he priced them not much lower than his oils. It is significant that when in 1873 he wanted to show his revered master, Jean Léon Gérôme, what he had accomplished in America, he chose to send him a watercolor of a man rowing; and after receiving Gérôme's letter criticizing his attempt to represent full motion, he evidently painted a new version, also in watercolor, and sent it to Gérôme.

One tantalizing feature of Eakins' watercolors is that five of the twenty-six have not so far been found. Aside from the two given to Gérôme, three of those exhibited at the watercolor society are still unlocated, including one that may well have been among his most important, judging by its price and its title: *The Pair-oared Race—John and Barney Biglin Turning the Stake* —probably a watercolor version of the big oil in the Cleveland Museum.

Almost all of Eakins' watercolors were products of his early manhood—his late twenties and his thirties—and they have the varied subject matter and the healthy extroversion of those years. In his forties, he was to abandon such subjects, except occasionally, and to concentrate on portraiture, attaining an increased breadth and mastery in this more limited field.

In selecting for the present volume this unfamiliar, but essential side of Eakins' life work, and in writing his perceptive and illuminating comments on it, Donelson Hoopes has made an important contribution to our understanding of one of America's greatest artists.

<div align="right">Lloyd Goodrich</div>

COLOR PLATES

PERIODICALS

Ackerman, Gerald M. "Thomas Eakins and His Parisian Masters Gérôme and Bonnat," *Gazette des Beaux-Arts,* LXXII (April 1969), p. 235 ff.

Burroughs, Alan. "Thomas Eakins, the Man," *Arts,* IV (December 1923), p. 303 ff.

Bregler, Charles. "Thomas Eakins as a Teacher," *Arts,* XVII (March 1931), p. 376 ff.; and (October 1931), p. 27 ff.

PAMPHLET

McHenry, Margaret. *Thomas Eakins Who Painted.* Overland, Pa., Privately Printed, 1945.

BOOKS

Barker, Virgil. *American Painting: History and Interpretation.* New York, 1950.

Goodrich, Lloyd. *Thomas Eakins, His Life and Work.* New York, 1933.

Novak, Barbara. *American Painting of the 19th Century.* New York, 1969.

Richardson, E. P. *Painting in America.* New York, 1956.

Schendler, Sylvan. *Eakins.* Boston, 1967.

EXHIBITION CATALOGS

Metropolitan Museum of Art, 1917. *Loan Exhibition of the Works of Thomas Eakins.* Introduction by Bryson Burroughs.

Pennsylvania Academy of the Fine Arts, 1917. *Memorial Exhibition of the Works of the Late Thomas Eakins.* Introduction by Gilbert S. Parker.

Museum of Modern Art, 1930. *Sixth Loan Exhibition of The Museum of Modern Art: Winslow Homer, Albert P. Ryder and Thomas Eakins.* Article on Eakins by Lloyd Goodrich.

Philadelphia Museum of Art, 1944. *Thomas Eakins.*

National Gallery of Art, Art Institute of Chicago, and Philadelphia Museum of Art, 1961. *Thomas Eakins, a Retrospective Exhibition.*

Whitney Museum of American Art, 1970. *Thomas Eakins.* Introduction by Lloyd Goodrich.

1844. Born July 25 in Philadelphia, Pennsylvania.

1846. Family moved to 1729 Mt. Vernon Street, Philadelphia.

1861. Graduated from Central High School in the upper quarter of his class. In the fall, began studying at The Pennsylvania Academy of the Fine Arts, principally under Christian Schussele in drawing. Took independent study of anatomy at Jefferson Medical College.

1866. To Paris in the autumn. Enrolled at the Ecole des Beaux-Arts. Studied under Jean Léon Gérôme and Léon Bonnat; studied sculpture under Augustin Alexandre Dumont. Classmates included Frederick A. Bridgman, Abbott H. Thayer, J. Alden Weir, and Wyatt Eaton.

1867. First use of oil color.

1868. Spent the summer traveling in France, Germany, Switzerland, and Italy.

1869. To Madrid and Seville in late November. His contact with the works of Velasquez and Ribera at this time became a formative influence in his work.

1870. Returned to Philadelphia in the late spring. Except for brief excursions to teach in New York and Washington, Eakins remained in Philadelphia for the rest of his life.

1871. Painted his first major canvas, *Max Schmitt in a Single Scull* (Metropolitan Museum of Art).

1872. His mother died. Became engaged to Katherine Crowell.

1875. Painted *The Gross Clinic* (Jefferson Medical College, Philadelphia).

1876. Five works accepted for exhibition at Memorial Hall, the Centennial Exhibition, Philadelphia. *The Gross Clinic* hung apart from his other works; considered too offensive for inclusion in the art section, and hung in the medical display. In April, The Pennsylvania Academy of the Fine Arts opened; Eakins became instructor in drawing in the Academy school.

1877. Painted first version of *William Rush Carving His Allegorical Figure of the Schuylkill River* (Philadelphia Museum of Art).

1879. Death of his fiancée, Katherine Crowell. Appointed Professor of Drawing and Painting in the Academy school. Painted *The Fairman Rogers Four-in-Hand* (Philadelphia Museum of Art).

1882. Appointed Director of the Academy school. Death of his sister Margaret.

1883. Painted *The Swimming Hole* (Fort Worth Art Association).

1884. Collaborated with Eadweard Muybridge at the University of Pennsylvania in the study of human and animal locomotion through sequential still photography. Married Susan Hannah Macdowell. Took up residence at 1330 Chestnut Street, Philadelphia, former studio of Arthur B. Frost.

1885. Returned to 1729 Mt. Vernon Street.

1886. Resigned Directorship of the Academy school under pressure from the Academy's board of directors, who objected to the use of nude models in the drawing classes. Art Students League (of Philadelphia) founded by some of Eakins' pupils from the Academy. Met Samuel Murray, with whom he formed a lifelong friendship.

1887. Trip to North Dakota in July; painted views of cowboy life. Returned to Philadelphia in October. Met Walt Whitman and began painting his portrait.

1889. Painted *The Agnew Clinic* for The School of Medicine, University of Pennsylvania. Death of his sister, Caroline Eakins Stephens.

1891. *The Agnew Clinic* rejected from exhibition at the Pennsylvania Academy.

1892. Art Students League disbanded. *The Agnew Clinic* rejected from exhibition of the Society of American Artists;

Eakins resigns his membership in protest. Painted *The Concert Singer* (Philadelphia Museum of Art).

1893. Exhibited at the Columbian Exposition, Chicago; awarded a gold medal.

1894. Published a paper on human musculature in the journal of The Academy of Natural Sciences, Philadelphia.

1896. Given a one-man exhibition (his first) at the Earle Galleries, Philadelphia. First invitation to exhibition of the Carnegie International, Pittsburgh.

1898. Painted important boxing picture, *Salutat* (Addison Gallery of American Art).

1899. Death of his father, Benjamin Eakins. Invited to serve on jury of the Carnegie International Exhibition.

1902. Elected Associate, then full Academician, National Academy of Design, New York. Began a series of portraits for St. Charles Seminary, Overbrook, Pennsylvania.

1903. Painted *Archbishop William H. Elder*, which won him a gold medal from The Pennsylvania Academy of the Fine Arts. Met John S. Sargent through a mutual friend, Dr. William White. Last year as a juror for the Carnegie International Exhibitions.

1905. Portrait of Professor Leslie Miller, painted in 1901, awarded prize by National Academy of Design.

1908. Returned to paintings on the theme *William Rush Carving His Allegorical Figure of the Schuylkill River*.

1910. Gradual deterioration of his health; few works completed from this year until his death.

1914. Philadelphia collector, Dr. Albert Barnes, purchased an oil study for *The Agnew Clinic*, paying a record price and helping to confirm Eakins' importance.

1916. Death of Thomas Eakins, June 25.

THOMAS EAKINS has achieved a paramount place among American artists, not because of the novelty of his particular vision of the world or his formidable technique as a painter but because of the penetrating truth of his statements. In the very pronounced academic way that Eakins approached his art, he is revealed as an exponent of a kind of science of recording visual phenomena, in contrast with the free, romantic spirit of his contemporary, James A. M. Whistler. Eakins always thought of himself as a "scientific realist," a term which summarizes aptly the clear assessment he made of his career. He was what we would call today an inner-directed person, and one of the very few American artists who did not allow his European training and experience to dominate his work.

Eakins successfully integrated European influences (Velasquez and Murillo from the past, Gérôme and Bonnat from his own time) with a strong, native American luminism to achieve a unique pictorial expression. Luminism sought to intensify the experience of reality by a heightened rendering of light and color, combined with linear precision and extreme clarity of detail. The luminist tendency is revealed particularly in his landscape and sporting pictures, and is most consistently maintained in his watercolors. In the watercolors, one is impressed with Eakins' almost compulsive concern with minute detail. There is the suggestion of a miniaturist at work; yet, largely because of his sensitivity to delicate nuances of tone, the watercolors take on an importance quite beyond their physical size.

Rather than simply employing watercolor as a sketching tool (as it had been regarded generally in the 19th century), Eakins frequently used the medium to achieve a final result. Winslow Homer seized on watercolor in the early '70s at exactly the same moment as did Eakins. But in spite of Homer's surer handling of the medium, Eakins' papers—barely a score of them in existence today—are much more intense creations.

The color scheme for *John Biglin in a Single Scull* (Plate 1), for example, was worked out in an oil study (Figure 2) before Eakins attempted the subject in watercolor. Yet the watercolor does not betray even the slightest suggestion of the laborious framework on which it was constructed, such as the mathematically precise perspective study (Figure 1). Moreover, Eakins achieved a sense of light and atmosphere in the sporting watercolors that many of his oils lack. Perhaps only the oil painting of *Max Schmitt in a Single Scull* (Metropolitan Museum of Art) completed in 1871, attains equal luminosity.

Eakins made very few watercolors, perhaps no more than thirty examples in all. They all date from the decade of the '70s and the early '80s, with two examples made as late as 1890. The production of watercolors corresponds roughly with the period in which Eakins was engaged mainly in painting outdoor subjects, before he turned to portraiture as his main activity. But why so few watercolors? The limitation on size imposed by the medium may be a partial explanation, since Eakins tended to paint portraits life size or nearly life size. And during the '90s, Eakins turned to portraiture almost exclusively. Few artists have been so insightful about human character, and for Eakins, portraiture seems to have been the logical culmination of his art.

Thomas Eakins was born in Philadelphia in 1844. His family derived from a working class background of farmers and craftsmen. His father, Benjamin Eakins, earned a modest living by teaching handwriting—"penmanship," as it was termed—in the fashionable private schools of the city. In a time when the manual arts were still flourishing, "Master" Benjamin supplemented his income by engrossing documents and presentation testimonials with his elegant steel-pen script. Son and father had a close personal relationship, and the elder Eakins imparted a love of drawing and his craftsman's diligence. The son became highly proficient as a draughtsman in school. Looking at his early drawings of simple machinery, such as lathes, one recognizes in them the same precisionist bent in American art which became formalized later in the work of Charles Sheeler (1883-1965). Other genial influences of the father are reflected in Eakins' early love of sports; rowing his single scull on the Schuylkill River or sailing on the Delaware and hunting for rail birds in the Cohansey marshes of New Jersey also said much about Eakins' individualism.

The pervading atmosphere of the Eakins house on unfashionable Mt. Vernon Street was one of companionship and a liberal parent-child exchange. Thomas was the firstborn and only son; his three sisters, Frances, Margaret, and Caroline, ranged in age from five to fifteen years younger. Parents and children were extraordinarily close in their affection for one another. Probably no other single influence sustained Eakins so well against the hostility his critics directed toward him in later years. The family house was the warm heart of his entire creative life; the integrated quality of his personality as an artist was due in no small measure to the benign and sustaining influence of his early home life.

Eakins graduated from Central High School in Philadelphia in July 1861, as the Confederacy dealt the Union forces its first defeat at Bull Run. He enrolled in the school of The Pennsylvania Academy of the Fine Arts and there he remained throughout the war; perhaps his excellence as a student earned him exemption from duty, or when military conscription loomed in 1863 his family may have been able to pay for a substitute.

The Academy was America's oldest continuing art museum, having been established in 1804 by Charles Willson Peale. It contained works of art of widely disparate merit—paintings of Biblical and allegorical subjects by Benjamin West were exhibited on an equal footing with plaster casts of classical sculpture. Instruction of students centered on drawing "from the antique," as the casts were called. Exactitude in rendering a charcoal drawing of the chipped and dusty plasters was stressed by the Academy's small faculty, headed by the ailing Christian Schussele (1824-1879), whose specialty was painting pictures laden with historical anecdote. There was drawing from the live model also, but this was mostly an extracurricular activity, paid for separately by the students, with the Academy lending the studio space.

Eakins hated the routine of the Academy, but deadly as the drawing classes were, he persisted in a methodical study of the human figure. Even at this early date, Eakins' concern for accurate scientific inquiry into human anatomy characterized the seriousness of his studies. On his own initiative, he applied to Jefferson Medical College in order to acquire a more thorough knowledge of human musculature and bone structure. Dissection of cadavers became a regular experience for him at Jefferson, and he probably acquired as complete a working knowledge as any medical student. In his respect for the human body, Eakins manifested a kind of Renaissance attitude: man was the center of all things, and the measure of creation. His art became consecrated to the human condition; without reference to people, even the landscape which he loved as a sportsman held no interest for him as an artist.

The Academy gave Eakins much practice in drawing the figure, and his studies at the medical college equipped him with a superb technical background—but he had no experience with handling color or with painting. He had exhausted the resources of the Academy and appealed to his father to send him to Paris. Although this must have placed a considerable strain on the family's finances, he was allowed to go.

During his time as a student at the Academy, Eakins had seen exhibitions dominated by grandiose history paintings, largely the works of popular European academicians. The native American landscape and genre painters—descendants of the Hudson River School tradition—merely looked old fashioned to Eakins' generation. The Barbizon School of Millet, Corot, and Daubigny, with its gentle, poetic view of the world, was just beginning to appear in the United States, especially in the more advanced private collections. Neither the pompous history paintings of older Europeans, nor the quaint and often sentimental pictures of the older native painters had anything to do with the world of these younger men.

Eakins saw the work of Jean Léon Gérôme (1824-1904) for the first time in the Academy's annual exhibitions. Although Gérôme was an exact contemporary of the fusty Schussele, his paintings seemed modern and exciting in Eakins' eyes. Gérôme practiced a precise style of drawing and painted in clear colors— a kind of commitment to realistic definition that touched a sympathetic response in Eakins. Gérôme's *Egyptian Recruits Crossing the Desert* was shown at the Academy in 1861 and 1862, and the harshly realistic subject must have seemed particularly strong when compared to the more usual exhibition fare, such as the *Birth of Venus* by Alexandre Cabanel (1823-1889), which the Academy bought for its own collection in 1863. The Cabanel was a replica of the original in the Musée du Luxembourg and represented the kind of official academic French painting that was attuned to the saccharine taste of Louis Napoleon's court; the Gérôme, on the other hand, was a painting created by a master of dramatic action and aimed for an emotional response, rather than a sentimental one. Gérôme was also unusual in that he did not require vast areas of canvas to present his themes; his highly charged and compact composition was perhaps the key that Eakins was looking for. Clearly, Gérôme was in Eakins' mind when he embarked for Europe from New York in September, 1866.

Until the decade of the '70s, very few Americans had ventured to Paris to study art. James Whistler had gone there to study under Charles Gabriel Gleyre in 1855, but virtually no other American followed him until Eakins. Eakins arrived in Paris with a knowledge of the French language gained from books and a determination to be accepted into the schools of the Académie des Beaux-Arts. The method of instruction at the school was rigid, and even to be accepted as a student required

an entrance examination, followed by an interrogation by a faculty member. Classes were given in studios presided over by a roster of notable teachers which, besides Gérôme, included Léon Bonnat (1833-1922), William Adolphe Bouguereau (1825-1905), Benjamin Constant (1845-1902), and Jules Bastien-Lepage (1848-1884).

After a month of waiting, Eakins was finally accepted into Gérôme's class. Gérôme had been a pupil of Paul Delaroche (1797-1856), who was a contemporary and rival of Delacroix and was even preferred to the latter by critics in his time. Delaroche, a member of the new romantic school, tended to return to academic modes of expression; thus his historical paintings for which he was famous really lacked the movement and force of true romanticism and have a decided penchant for merely descriptive and literary values. Gérôme owed as much to Delaroche as he did to Ingres whose dictum, "the integrity of art lies in drawing," he pursued relentlessly. Into this mixture of historical academicism and neo-classicism, Gérôme incorporated a third element, Orientalism. This was one of the most pervasive influences of mid-19th century academic painting; unfortunately for Gérôme, the exotic appearances of Oriental life appealed primarily to his sense of the picturesque and rarely evoked a more profound expression.

Gérôme had other American students—Frederick A. Bridgman (1847-1927) and Edwin Lord Weeks (1849-1903)—on whom he exerted an overwhelming influence, but Eakins resisted the seduction of the picturesque-romantic mode. Gérôme was a dedicated craftsman, whose disciplined working methods Eakins found useful for improvement in drawing. Not until the following spring, in March 1867, was Eakins permitted to use color in his studies of the life class models. The problems he found in handling color relationships, complicated by learning how to use a new medium of oil paint, discouraged him. In the fall, he rented a private studio and threw himself into the task of mastering problems of light and form with oil color. He wrote home, "Gérôme told me . . . to paint some bright-colored objects, lent me some of his Eastern stuffs, which are very brilliant, and I am learning something from them faster than I could from the life studies."

These letters to his family reveal an ambivalence toward his dogmatic teacher, but the overall impression is that Eakins benefited from the experience. Eakins regarded color as a perplexing mystery. If he could only solve that mystery, he would

cease making studies and begin to paint pictures in earnest. When he erred, as in a portrait class, the master applied a perfunctory correction, "Gérôme just painted [the] head right over again, and this I take as an insult to my work." Years later, as a teacher himself, Eakins often instructed by the same kind of direct demonstration, painting into his students' work. Gérôme showed him that painting instruction is largely a matter of practical example, not theory. As for problems of composition and style, Gérôme gave scant advice, preferring that the student work out his own solutions.

The manner in which Eakins made analogies between life and art in his letters reveals the practical, homespun way in which he approached problems of aesthetics in art. He compared adjusting his palette of colors to tuning a fiddle; learning painting technique by trial and error to learning how to ice-skate; and improvising on nature's realism to sailing a boat. Eakins was no aesthetician, but he was able to translate the abstract principles of aesthetics into practical terms which became a part of his daily life.

The phrase, "solid work," appears frequently in his letters and reveals the overriding passion of his artistic life, which was to create a palpable realism in his paintings. During these student days, this preoccupation led him into an admiration for technical proficiency irrespective of the ends it might serve. He once commented that a painting by Mariano Fortuny (1839-1874) was "the most beautiful thing I have ever seen." Today, Fortuny's pictures seem parodies of candy box style and puerile subject matter, but Fortuny was a master at creating the semblance of an incredible variety of textures, and he could incorporate and control a prodigious range of color. Clearly, Eakins was blind to Fortuny's subject matter and saw only his virtuoso technique. And compared with the vaguely salacious, pseudoclassical female nudes that abounded in the Salon exhibitions, the highly finished realism of Gérôme and Fortuny must indeed have seemed like "solid work."

At the moment when Eakins was discovering his own way as an artist, there was another kind of realism in the air of the Paris art world. Gustave Courbet and Edouard Manet led the advance against official art by rejecting history painting and other forms of sentimental fiction in favor of the world as they saw it around them. Eakins took no evident notice of them, nor did he report to his family the sensation they created at the Exposition Universelle of 1867. The jury of the Exposition had rejected their

works, and in an act of defiance, both artists constructed temporary wooden sheds in which they displayed their paintings outside the Exposition grounds. As a curious comment on the times, a portrait of Manet by Fantin-Latour could be seen at the Salon of 1867; the artist portrayed Manet as a respectable gentleman, fastidiously tailored and in a top hat, which was acceptable to the genteel jurors of the Salon, while the artist's real self, as reflected in his rejected paintings, was officially discredited.

As if to underscore the pervading mood of official repression in Paris that year, Manet could not exhibit his *Execution of Emperor Maximilien* for political reasons. Napoleon III was not prepared for such graphic reminders of the transitory history of imperial dynasties. Manet survived the war that toppled Napoleon III in 1870, and went on to draw scenes of the aftermath of civil disorder. During this same period, all of those artists who were struggling toward that other revolution which would come to be called "Impressionism"—Pissarro, Cézanne, Monet, Renoir, and Sisley—constituted the vital center of artistic activity in Paris.

There is no evidence that Eakins had taken any notice of these movements or the personalities associated with them. His point of view was precisely opposed to Impressionism—the object of his studies was to isolate and define the particular; while the element of light was important to these studies, it was the quality of light in sharp focus that created individual character. Thus, Eakins' search was not for general truths about nature as the Impressionists would have it, but for a humanist approach to the specific. Landscape painting and still life, whether that of the Academicians or of the Independents, could hold little interest for him. Moreover, in his abhorrence of the work of the great majority of traditional Salon painters, Eakins belonged to no identifiable group.

His admiration for Gérôme led him to look at those masters of the past who were admired by his teacher. Gérôme was part Spanish and so was Sargent's teacher, Carolus-Duran. It is interesting to note how Gérôme inculcated Eakins' admiration for Murillo and how Carolus-Duran imparted to Sargent an enthusiasm for Velasquez. Manet had begun the craze for Spanish subject matter in the '60s, with his exhibition of a number of paintings of Spanish dancers, notably his portrait of *Lola of Valencia*. But Eakins was the first important American painter to "discover" 17th century Spanish art. In the fall of 1869, he wrote to his father, "I feel now that my school days are at last

over and sooner than I dared hope . . . I am as strong as any of Gérôme's pupils, and I have nothing now to gain by remaining." With the onset of the late autumn rains in Paris, Eakins decided that this was the moment to seek a more agreeable climate. He set out for Spain, arriving in Madrid on the first of December, 1869.

In the Prado, he saw for the first time the full scope of 17th century Spanish painting, and the impact of these pictures moved him deeply. He wrote, ". . . what a satisfaction it gave me to see the good Spanish work, so good, so strong, so reasonable, so free of every affectation." Lloyd Goodrich, in his biography of Eakins, identified the magnetic attraction between Eakins and the Spanish masters: ". . . the closest to his own temperament was [that of] the Spaniard, with his naturalism, his concern with the facts of everyday life, his love of character more than ideal beauty, his scientific objectivity." Rembrandt and Titian also became more important to Eakins as he began to explore the techniques of painting in transparent glazes. He saw immediately the limitations of Gérôme's opaque technique, and was mature enough to understand that Gérôme, with all of his obvious faults as an artist, had been a good and necessary step in his own development. He remained in Spain—mostly in Seville—for six months. Then, in the spring of 1870, he returned to Paris for a brief visit before taking ship to New York.

His three and one half years in Europe were marked by an intense application to art that permitted him little time for making many friends or engaging in the Bohemian life of the typical art student. His best friends during these years were, curiously, Philadelphians also. William Sartain (1843-1924) had been a fellow student at the Pennsylvania Academy and had followed Eakins to Paris, where he became a student of Bonnat. Sartain's father, John Sartain (1808-1897), was an English mezzotint engraver who had emigrated to Philadelphia and established himself as editor of *Sartain's Union Magazine of Literature and Art*. Eakins' other companion in Europe was Henry H. Moore (1844-1926), who was already a pupil of Gérôme when Eakins arrived in Paris. Moore's family had come with him to care for him, since he was totally deaf since birth and could converse fluently only in hand signs. Eakins learned sign language in order to communicate with Moore, perhaps enjoying the challenge of learning a new language as much as he had enjoyed teaching himself French. These Philadelphians provided Eakins with the necessary spiritual ties to his home;

the importance of this tie is demonstrated by his effort to overcome the difficulties involved in communicating with Moore.

Eakins returned to Philadelphia in July 1870 and immediately resumed residence in his father's house on Mt. Vernon Street. A studio was fitted out for him on the top floor and he began painting immediately, choosing his sisters in the family parlor for his subject matter. In 1871, he began work on a picture of a boyhood friend rowing on the Schuylkill River: *Max Schmitt in a Single Scull* (Metropolitan Museum of Art). Such a subject had never appeared before in American painting. At twenty-seven, Eakins already showed a prodigious mastery; he had successfully established a bridge between his own heritage of luminism and the clarity of color and precision of drawing of his European teachers. He surpassed Gérôme in this picture precisely because he understood that light is transparent and must be rendered transparently. Moreover, his sense of spatial relationships is refined in the Schmitt picture to a point which vindicates his scientific realism in both a pictorial and a mathematical way.

In the early '70s, Eakins was painting pictures from two distinct points of departure. The intimate world of his family, with its enclosed space, was being handled in a controlled studio manner, employing a single source of light, while his landscape subjects—mostly Schuylkill River scenes with rowers—were statements concerning the quality of diffused, enveloping light. The emphasis of his work was upon the study of the broad light of nature, whether he was painting his many versions of the professional oarsman or his scenes of hunting in the New Jersey marshes.

Eakins resumed his studies of anatomy at Jefferson Medical College and formed friendships with members of the teaching staff. In particular, the strong, independent character of Doctor Samuel Gross appealed to Eakins, who saw in the surgeon something of his own self-reliance. It has been suggested that Eakins determined to paint Gross in emulation of Rembrandt's *The Anatomy Lesson of Dr. Tulp*. Rembrandt had created an immediate reputation on the basis of this picture, and Eakins, returning from Paris full of confidence in his own powers, needed to call attention to himself in some dramatic way.

In *The Gross Clinic* of 1875, Eakins turned from his accustomed bright palette to somber colors and dramatic chiaroscuro that strongly suggested not only Rembrandt, but also the Spanish masters of the 17th century. The painting is not a portrait in the conventional sense, but was conceived as a pictorial environment with lifesize figures, expressing the artist's heightened ideal of realism. Though clearly based on well-established precedent, the Gross portrait was highly innovative. Eakins knew this painting to be a most important work and submitted it to the art jury of the Centennial Exhibition of 1876. The painting was rejected, presumably because of its uncompromising realism in treating the subject of a surgical operation in progress. *The Gross Clinic* was finally exhibited in the medical section of the Centennial Exhibition, along with displays of equipment. The painting received abusive criticism in the press, reflecting moral outrage at a subject that offended the public's genteel sensibility. Eakins found it impossible to sell the painting until three years later, when Jefferson Medical College bought it for two hundred dollars.

Eakins must have been profoundly disturbed by the treatment accorded *The Gross Clinic* and by the invective heaped upon him personally as one who had created "a degradation of Art." While he understood the basis of such criticism, he knew it to be utterly irrelevant to art. Realism, if it were to be a viable form of expression, could not shrink into comfortable pictorial pleasantries. Above all, his art was an expression of his own personality; and he spoke, behaved, and painted with equal candor and disregard for meaningless conventions.

It would be wrong to assume, from *The Gross Clinic* fiasco, that Eakins had been banished, like some American Courbet, from the great official exhibition. Quite the opposite, for inside the art section of the exhibition were five works by him, duly passed and accepted by the jury of selection. These pictures—including two watercolors, *Baseball Players Practicing* (Plate 6) and *Whistling for Plover* (Plate 3)—offered no disturbing scenes. One of them, a small oil painting showing three distinguished elderly men in an ornate parlor—*The Chess Players* (Metropolitan Museum of Art)—was a very model of dignity and good taste.

Despite his unwillingness to paint a merely conventional portrait of Doctor Gross, Eakins' aim was not to offend public sensibility. He was making his way in the Philadelphia art world through the very doors of its conservative establishment, The Pennsylvania Academy of the Fine Arts. The new Academy building at Broad and Cherry Streets, which had been erected uptown from its old location on Chestnut Street (not far from the Eakins house on Mt. Vernon Street), was designed by a

young Philadelphia architect, Frank Furness. The Academy opened its doors in April, 1876, with exhibition space over the ground floor where the school was located. The new Academy building was a kind of masterpiece of inspired compromise in design; and Eakins might well have read the portents for the future in it. Furness had created an imposing eclectic facade out of Gothic and Renaissance motifs, with an interior inspired by the fashionable formulas of Eastlake's principals of decorative design. The psychological effect of having the school space dominated by the museum was ever to be subtly demonstrated in the years ahead.

Eakins became an assistant to his old instructor, Christian Schussele, in 1878, and succeeded him as professor of drawing and painting in the fall of 1879, following Schussele's death. Eakins was regarded as a radical by the conservative Philadelphia gentlemen who underwrote the Academy's operations and who sat on its autocratic board of directors, guiding its future. Eakins' appointment probably reflected the inertia of the board, which kept them from looking for a less controversial figure; however, when he was appointed to assume control of the school's teaching, Eakins accepted and immediately advanced his own beliefs over the established teaching process. Fixing an experienced and disillusioned eye on many of the "antique" casts he had been obliged to draw as a student, Eakins said: "I don't like a long study of casts . . . the beginner can at the very outset see more from the living model in a given time than from the study of the antique in twice that period." He also determined to shorten the period of drawing from plaster casts which typified Schussele's approach; "I think [the student] should learn to draw with color; the brush is a more powerful and rapid tool than [the pencil] . . . There are no lines in nature . . . only form and color."

Thus began Eakins' revolution in teaching at the Academy. Dedicated as he was to arriving at a scientifically truthful, yet artistic solution to the problem of figure painting, Eakins encouraged his students in ways that the administration was certain to resent and fear. Whereas Eakins regarded the human body as a thing of beauty, the society in which he lived equated nudity with sin. Eakins himself was not inclined to paint a nude for its own sake: "I can conceive of few circumstances wherein I would have to paint a woman naked," he wrote to his father in 1867. When he finally came to the right "circumstance" ten years later, Eakins produced one of the most beautiful paintings of his

career. *William Rush Carving his Allegorical Figure of the Schuylkill River* (Philadelphia Museum of Art) is a title invented to dispel any possible suspicion in the mind of the public that the painting might not be a representation of a purely historical scene, rather than the ravishing nude study that is really the subject of the composition. Eakins admired the colonial sculptor William Rush (1756-1833) as a kindred spirit who looked to the human figure for his inspiration also. Rush's model did not pose nude: that was pure invention by Eakins.

Eakins was sustained in his position at the Academy by its board chairman, Fairman Rogers. Besides his attainments in engineering, which gave him a solid basis of respectability in the community, Rogers held a keen interest in art and scientific studies. He upheld Eakins' teaching methods as appropriate for a school which sought to develop professional artists, rather than amateurs. Rogers engaged in the elegant sport of coaching and maintained a large stable of horses at his farm west of Philadelphia. Out of their friendship and mutual interests—Eakins studied equine anatomy and offered additional lessons on this subject at the Academy—the painting *The Fairman Rogers Four-in-Hand* (Philadelphia Museum of Art) was conceived.

Up to this time, horses in motion were generally represented in art by a convention which showed leg movement in a stylized way that the trained observer knew to be false. Few artists before Eakins had bothered to investigate the actual conformation of a horse in motion. This he did in many preparatory studies, made while the coach-in-four passed before him as he studied each of the horses one by one. In order to better his understanding of this complicated subject, Eakins made wax models of the horses. But it was not until 1884 and his association with Eadweard Muybridge at the University of Pennsylvania that Eakins was fully able to realize scientific exactitude in the study of motion.

Muybridge's method was to set a series of still cameras in line, a few feet apart, and to actuate each camera in sequence as the moving subject passed before them. Eakins' modifications produced the first true motion picture—proved many theories about animal and human motion and gave Eakins an important tool in his search for a realistic representation of life. However, Eakins did not use photographs directly to paint pictures; the photograph was only a tool in his hands. When he was ready to paint a picture, he did so directly with the brush and with no elaborate preparatory drawing.

With the resignation of his good friend Rogers from the

Academy's board came a turning in Eakins' fortunes. Rogers had prevailed in getting Eakins appointed director of the school in 1882, but an unfortunate matter occurred that spring. One of the young ladies in the life classes wrote a lengthy diatribe to the president of the Academy, protesting the exposure of the "horrid nakedness" of male and female models. The following year, Eakins was commissioned to paint *The Swimming Hole* (Fort Worth Art Association) for one of the Academy's board members, who then rejected the painting in favor of one with more conventional subject matter. Perhaps the enthusiasm and liberalism that Rogers had brought to the Academy's board had been momentarily infectious, but with his departure, stodgy industrialists resumed their normal attitudes about art.

In *The Swimming Hole*, Eakins portrayed a group of six men, nude and enjoying nature in a kind of Whitmanesque abandonment to sunshine and water. Eakins knew that the nude figure was best observed and sketched outdoors in the context of sunlight and landscape, rather than in the artificial light of the studio. Other scenes of nude figures set against landscapes—mostly on the theme of Arcadia—suggest Eakins' yearning to be free of the restraints that his society had placed upon the human spirit. (Henry Adams, reflecting on this problem, had observed that the repression of sensuality had been one of the principal triumphs of society.)

By 1882, death had come to three persons who had been very close to Eakins: his mother, in 1872; his fiancée of seven years, Katherine Crowell, in 1879; and his sister Margaret, in 1882. Margaret had posed for many of his pictures, including the two watercolors which bear the title, *Spinning* (Plates 19 and 21). With the outside world setting itself against him, Eakins must have cherished the warmth of family ties more than ever. In 1884, he married one of his students, Susan Macdowell, and for the first and only time, took up residence away from the family house on Mt. Vernon Street. The new studio-apartment on Chestnut Street had belonged to the illustrator, Arthur B. Frost (1851-1928), whose portrait Eakins painted at about this time. Frost had studied under Eakins at the Academy night school and considered this instruction the most important influence in his career. But the Eakinses gave up the studio after only one year and moved into the family house. The old attachments were strong. His career was not going well—there were intimations of trouble with the Academy administration and he had not been able to realize the kind of income from his painting that would

have granted him independence. Eakins kept a notebook of his transactions between 1870 and 1880, which recorded the sale of only eight paintings in this period, for a total income of something more than $2000. He had shown his work at every possible opportunity, from the prestigious exhibitions of the National Academy of Design, the Society of American Artists, and the American Watercolor Society to regional fairs and industrial exhibitions.

1886 was a lean year for Eakins. He painted only three portraits and one of these was not a commission—the sitter was his brother-in-law, Frank Macdowell. All of the minor incidents relating to the study of the nude at the Academy, under Eakins' leadership, came to a crisis point that year. A full-blown scandal finally erupted when Eakins, demonstrating the muscle function of the pelvis of a male model, removed the loincloth before the eyes of some women students. Eakins had determined that the business of studying the human figure was ". . . not going to benefit any grown person who is not willing to see or be seen seeing the naked figure . . ." and he had at last thrown aside all caution as an impediment to his teaching. The ensuing uproar lead to his censure and an admonition from the board to refrain from using a totally nude model ever again. Rather than compromise his standards, Eakins rejected the conditions under which he could remain at the Academy and resigned under pressure in February 1886.

A loyal group of students immediately formed an independent school with Eakins at its head. They found quarters in a commercial building a few blocks south of the Academy on Market Street. It was called The Art Students League, probably emulating the independent school of this name founded in New York in 1875 as a reaction against the National Academy of Design. There was a feeling of revolution in the air among art students in the two cities. In Eakins' new school were men who had seen action in the Civil War; the school's first curator had been a captain of cavalry. These were mature men who resented the patronizing attitude of the art establishment toward students. The release from his struggle with the Academy administration was good for Eakins and for the students who came over to him. The League was operated in an egalitarian fashion; Eakins accepted no pay for his teaching, and the tuition was kept to a minimum, although operating funds were often short.

Out of the League experience, Eakins acquired a lifelong friend in Samuel Murray, a young sculptor who stayed on with

him to share his studio for ten years. Eakins assisted Murray in creating architectural sculpture for new buildings in Philadelphia. This was a field which Eakins entered in the '90s, making bas-relief sculpture for Memorial Arch at the entrance to Brooklyn's Prospect Park and for the Battle Monument at Trenton, New Jersey.

His involvement in the creation of the Art Students League must have helped to heal the psychological wounds caused by his dismissal from the Academy. But nearly a decade after the event, he still recalled the incident with mild, but unmistakable bitterness: "I taught in the Academy from the opening of the school until I was turned out, a period much longer than I should have permitted myself to remain there. My honors are misunderstanding, persecution and neglect, enhanced because unsought."

After the conclusion of the first year of the League's operation in 1887, Eakins decided to spend the summer at the Dakota ranch of his friend Dr. Horatio Wood, a distinguished faculty member of the University of Pennsylvania School of Medicine. He went alone—Susan Eakins remained in Philadelphia and their parting for the first time in three years of marriage suggests the depth of his discouragement. Eakins evidently needed a solitude that would not admit even of his wife. In 1885, Eakins had painted a portrait of his bride, *A Lady with a Setter Dog* (Metropolitan Museum of Art), full of rich, glowing color that distracts attention from the melancholy expression of the face and the listless posture of the figure. Eakins' portraits, to a remarkable extent, are reflections of his own somewhat dour personality. His perception of the tragic element in the human experience was profound. In Dakota, Eakins engaged fully in the outdoor life, taking daily horseback rides and sketching scenes of cowboy life and the landscape of the Badlands. Several of these sketches became fully realized the following year in his studio in Philadelphia, notably one of his rare landscape pictures, *Cowboys in the Badlands* (private collection), and the subject of the cowboy singing received a number of treatments.

Eakins returned to Philadelphia refreshed and apparently ready to make another serious commitment to his art. In view of the dismal fate of *The Gross Clinic*—it had been exhibited once at the Academy in 1879 under the most unpleasant circumstances for Eakins—it seems particularly optimistic of him to embark upon a second composition whose character is so similar to the Gross subject. In 1889, Eakins accepted a commission to paint *The Agnew Clinic*, paid for by students of Dr. D. Hayes Agnew,

who was retiring from his teaching position at the Medical School of the University of Pennsylvania. Once again, Eakins chose to show the doctor at work in an operating amphitheater, rather than giving him a conventional portrait treatment. And again Eakins described in vivid detail an operation in progress—this time exposing a breast to view. The painting was finished in three months and came under attack from the conservative art establishment almost at once, when it was shown for the first time in a commercial gallery. In 1891, the Academy quite predictably refused to hang the painting in its annual exhibition, explaining that the rejection was based upon its having been shown previously. The real reason came forward eventually: the painting was "not cheerful for ladies to look at." Twelve years had elapsed between the Academy's rejection of *The Gross Clinic* and its triumph in excluding *The Agnew Clinic*; the Academy still regarded Eakins as an outlaw of art.

His friend Harrison Morris, who became managing director of the Academy, was much the same kind of influential friend as Fairman Rogers had been. Morris believed that "A city with Eakins living in it detached from its Fine Arts Academy was a . . . farce. You might as well try to run a wagon on three wheels . . ." Morris lured Eakins out of his isolation and from 1894 until the end of his painting career, Eakins exhibited in the Academy's annual exhibitions on a more or less regular basis. The Academy officially ended its vendetta against him in 1897 with the purchase of *The Cello Player*.

Eakins lived to see his values as an artist vindicated, but he continued to suffer discouragements. 1892 had been a particularly disappointing year; his Art Students' League was forced to disband after six years because of lack of financial support. The Society of American Artists—that once-liberal group turned conservative with whom Eakins had exhibited regularly since its inception—rejected *The Agnew Clinic* in 1892. Eakins resigned his membership in the Society in protest.

He was not dismayed by others' lack of confidence. Eakins had worked laboriously for two years on *The Concert Singer* (Philadelphia Museum of Art) and perhaps the aria, *O rest in the Lord*, from Mendelssohn's *Elijah*, sung to him by the model every day during the sittings, gave him more than just the observation of throat muscles in action. The painting proved to be one of his most poetic · d colorfully resonant. Eakins began to concentrate on portraiture in the '90s; even though fashionable members of Philadelphia society shunned his services, he

found plenty of patronage from doctors, professional men, and musicians in the community. Toward the end of the decade, Eakins returned to sporting scenes—boxing and wrestling interested him now. He gave to boxing, as in *Salutat* (Addison Gallery of American Art), the same immediacy in paint that he had bestowed on the drama of the surgical amphitheatre. The boxing scenes are faithful mirrors of the atmosphere of the ring at the turn of the century, straightforward and free of clichés.

The decade of the '90s also produced for him the first stirrings of national recognition: a gold medal at the Columbian Exposition in Chicago in 1893 and, three years later, an invitation to exhibit at the Carnegie International Exhibition in Pittsburgh. At home, too, he had a measure of public acclaim: the Academy of Natural Sciences published his paper, *The Differential Action of Certain Muscles Passing More than One Joint*. His first one-man show occurred in 1896 at the Earle Galleries in Philadelphia, and it could not be said that he was ignored by his city. Just after the turn of the century, Eakins became a full member of the National Academy of Design in New York—a place where he had given much of his time in teaching—and respect-

ability seemed to be conferred on him at last. John S. Sargent sought him out and was introduced to Eakins by a mutual friend, William White, with whom Sargent was staying while completing a portrait of Mrs. Joseph Widener of Philadelphia.

Honored in New York, Eakins was still a prophet without much honor in his own land, however. It was not the monied classes of Philadelphia's Main Line who sought his services, but a group of Catholic prelates of St. Charles Seminary. The collection of Eakins portraits accumulated at the seminary during the latter part of Eakins' career represent some of his finest achievements in the art of portrait painting.

At the last, Eakins reached back over thirty years to recall the theme of William Rush and the allegory of the Schuylkill River. His ideal of representing the human body in art with monumentality and dignity—an ideal which had caused him a lifetime of ostracism—was reaffirmed in the 1908 version of the Rush theme with an undiminished force and beauty. Until his health began to fail in 1910, Eakins remained a powerful artist, a clear eye, and a perceptive mind in an uncompromising search for a vision of the truth.

PLATES

Plate 1

JOHN BIGLIN IN A SINGLE SCULL

1873-74
17⅛" x 23" (43.4 cm. x 58.4 cm.)
The Metropolitan Museum of Art, Fletcher Fund, 1924

John Biglin in a Single Scull. Shortly after Eakins returned from Paris in 1870, he began working on a series of pictures whose subjects were the Biglin brothers. The Biglins were professional oarsmen whom Eakins got to know because he himself enjoyed rowing in the single scull. Eakins' meticulous care and attention to detail in constructing a picture is perhaps nowhere better demonstrated than in the step-by-step preparation for this water-color.

In its creation, Eakins seems to have continued to rely upon the guidance of his former teacher in Paris, Gérôme, maintaining a frequent correspondence with him. In the spring of 1873, Eakins sent Gérôme a trial watercolor whose subject was also the rower, Biglin. Although this first version is now lost, a letter from Gérôme to Eakins, in which the master gives a critique of the picture, reveals its probable appearance.

Gérôme commented: "The individual who is well drawn in his parts lacks a total sense of movement; he is immobile, as if he were fixed on the water; his position I believe is not pushed far enough forward—that is, to the extreme limit of movement in that direction. There is in every prolonged movement, such as rowing, an infinity of rapid phases, and an infinity of points from the moment when the rower, after having leaned forward, pulls his upper body back as far as it will go. There are two moments to choose from for painters of our sort, the two extreme phases of action, either when the rower is leaning forward, the oars back, or when he has pushed back, with the oars ahead; you have taken an intermediate point, that is the reason for the immobility in the work."

The first watercolor was presumably returned to Eakins, who may have destroyed it. He immediately began work on a second version, incorporating into it the suggestions made by Gérôme. In the perspective drawing (Figure 1) for this watercolor, it may be seen how Eakins approached the subject with mathematical precision. It is drawn almost exactly twice the size of the finished watercolor. With such an enlargement, Eakins could more precisely study the problem of perspective involved in this very complicated subject. While superficially appearing to be a profile view of the rower and his boat, it is actually not a profile, but a very subtle three quarter view. As the perspective drawing shows, the imaginary lines which create depth in the picture all vanish at a point directly behind the head.

In order to work out the problems of form involved in the figure of the central subject, Eakins resorted to oil paint. The oil study is larger than the watercolor and notably richer in color, due to the greater strength of the oil medium. Yet the transparency of the watercolor permits a much more subtle range of tones, giving a much more convincing atmospheric perspective. The figure of Biglin is rendered with solidity and with such attention to detail that it runs the risk of being a static thing. By injecting such elements into the composition as the water dripping from the blade of the oar and the prow of a scull entering the picture from the left, Eakins has suggested the transistory moment.

Eakins also sent this second version to Gérôme in Paris and it was returned to him with a letter from his master, which said: "Your watercolor is wholly well-made." In 1874, Eakins entered the work in the annual exhibition of the American Society of Painters in Water Colors, an organization which had been established in New York in 1867, in recognition of the growing interest in watercolor among American artists.

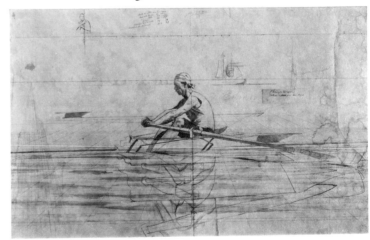

Figure 1. *Perspective Study for John Biglin in a Single Scull,* ca. 1873-74, pencil, ink, and wash on paper, 27⅜" x 45³⁄₁₆" (69.5 cm. x 114.8 cm.). Museum of Fine Arts, Boston, Gift of Cornelius Vanderbilt Whitney.

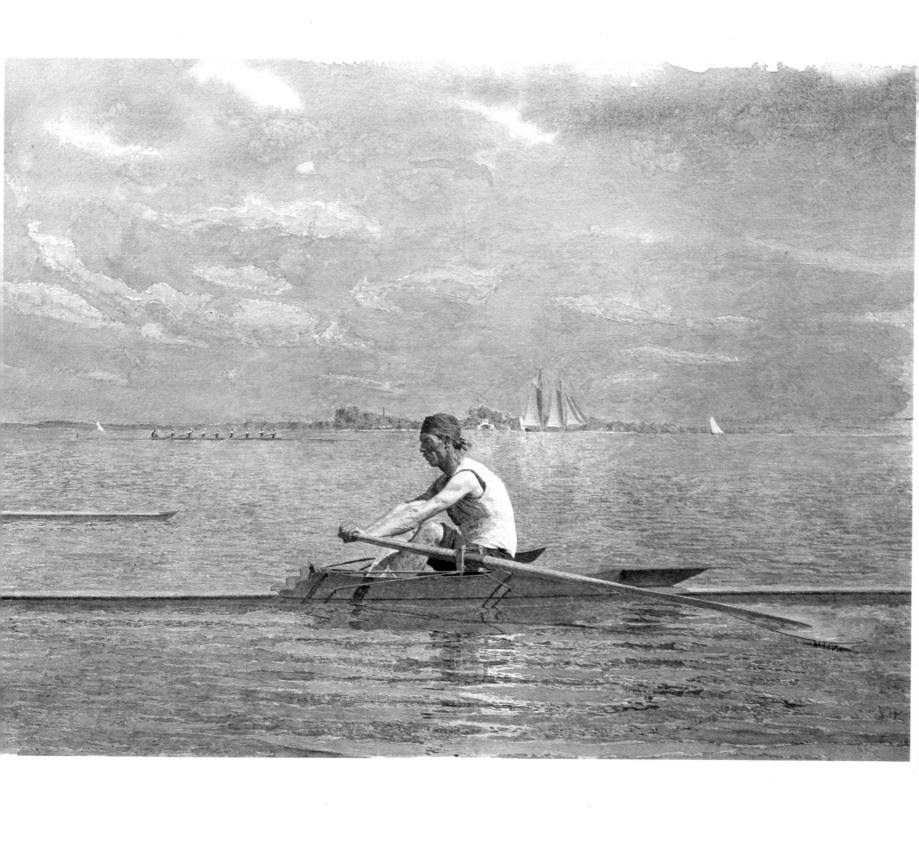

Plate 2
JOHN BIGLIN IN A SINGLE SCULL
Detail of Plate 1, Actual Size

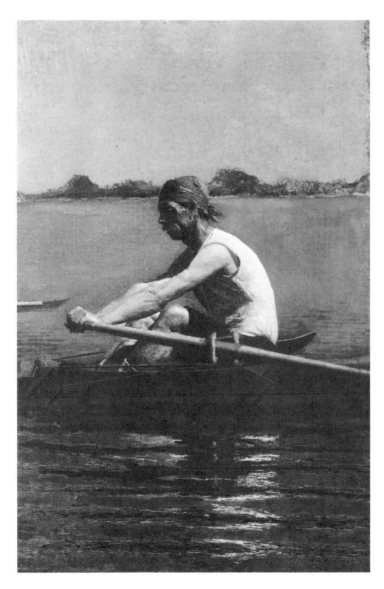

Figure 2. *John Biglin in a Single Scull,* 1874, oil on canvas, 24⁵⁄₁₆″ x 16″ (61.8 cm. x 40.6 cm.). Yale University Art Gallery, Whitney Collection of Sporting Art.

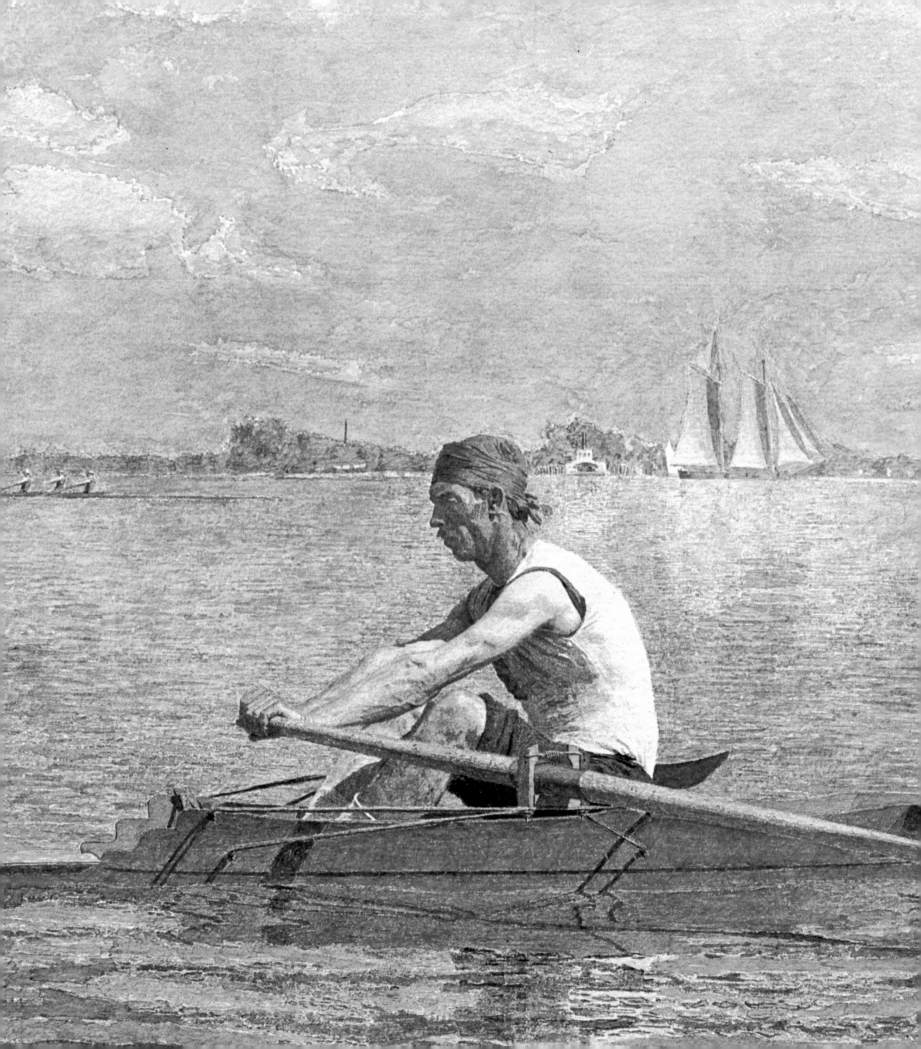

Plate 3
WHISTLING FOR PLOVER
1874
11″ x 16½″ (27.9 cm. x 41.9 cm.)
The Brooklyn Museum

While Gérôme was assisting Eakins in Paris—not only through constructive criticism, but also with his help in placing Eakins' work in collections and in the Salon exhibitions—another friend, Earl Shinn (1838-1886), was helping him in New York. Shinn was a native Philadelphian and he had also been a student of Gérôme in Paris. But most important, he was the art critic for *The Nation* between 1868 and 1886.

In January, 1875, Eakins wrote to Shinn from Philadelphia: "You will see in the watercolor exhibition [American Society of Painters in Water Colors] three little things of mine . . . a negro whistling for plover. This is the same subject as my oil and the selfsame Negro William Robinson of Backneck but in a different position. It is not near as far finished as the little oil one but is painted in a much higher key with all the light possible." The "little oil one" is a reference to an oil painting which Eakins sent to the Salon in Paris that year. The oil version was sold through Goupil, and its whereabouts are unknown today.

It is interesting to note that Eakins' letter refers to the watercolor as being painted "in a much higher key with all the light possible." The watercolor has an overall pearly light, achieved by a very high keyed color scheme. To judge from the letter, Eakins must have been looking for a means of painting light in a way that he found impossible in oils. But because of his manner of working—with close attention to minute detail—the creation of a finished watercolor must have been extremely tedious. Even more than in the Biglin watercolor (Plate 1), Eakins seems to have depended on drawing, rather than on broad washes of color. The areas of local color are rendered with staccato touches of the brush. Eakins has taken Gérôme's idea about the phases of action in rowing, translating it into the terms of this picture. We are given a split second in time—the moment when the hunter utters a whistle to call the birds and is preparing to close his shotgun and aim at them. In a moment, he will rise from his crouching position and fire. The sense of expectation that this small image creates is extraordinarily powerful.

Whistling for Plover was one of the five works Eakins exhibited in the Centennial Exhibition in Philadelphia in 1876. Shortly thereafter, he presented the watercolor to a man he admired greatly, Dr. Silas Weir Mitchell (1829-1914) the Philadelphia physician, novelist, and poet.

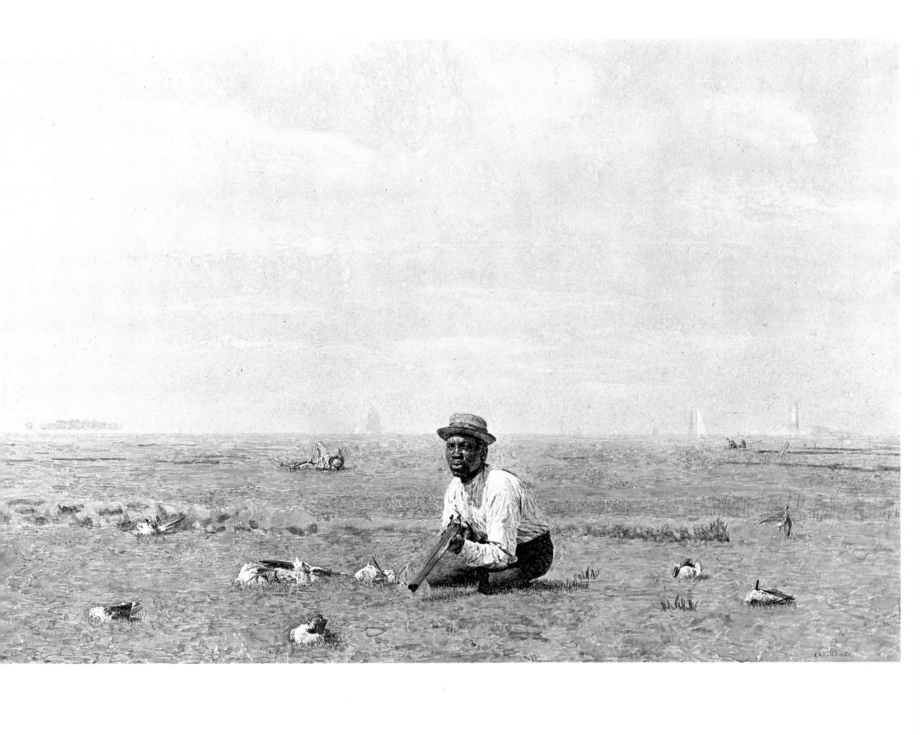

Plate 4
STARTING OUT AFTER RAIL
1874
25″ x 20″ (63.5 cm. x 50.8 cm.)
Wichita Art Museum, Murdoch Collection

Two versions in oil preceded the watercolor that Eakins finally painted in 1874. The first version was a horizontal composition, rather sketchily painted. This he gave to his close friend, William Merritt Chase (1849-1916), in 1900. The second composition is identical with the watercolor, both in composition and in size. It was the second and more finished oil painting that Eakins sent to Goupil, his dealer in Paris, in 1874. The watercolor version, however, was exhibited at the Seventh Annual Exhibition of the American Society of Painters in Water Colors in New York, during the spring of 1874. In the exhibition catalog, Eakins identified the picture as *Harry Young, of Moyamensing, and Sam Helhower, "The Pusher," Going Rail Shooting.* (A pusher is a poleman in a punt.) The watercolor was later shown at the 52nd annual exhibition of The Pennsylvania Academy of the Fine Arts in 1881.

The picture shows two of Eakins' friends setting out in a small catboat across the Delaware River to the hunting marshes in New Jersey. Eakins once remarked in a lecture: "I know of no prettier problem in perspective than to draw a yacht sailing. A vessel sailing will almost certainly have three different tilts. She will not likely be sailing in the direct plane of the picture. Then she will be tilted over sideways by the force of this wind, and she will most likely be riding up on a wave or pitching down into the next one." Nowhere is Eakins' interest in the subject better demonstrated than in this picture.

Figure 3. *Starting Out After Rail*, 1874, oil on canvas, 24″ x 20″ (60.9 cm. x 50.8 cm.). Museum of Fine Arts, Boston, Charles Henry Hayden Fund.

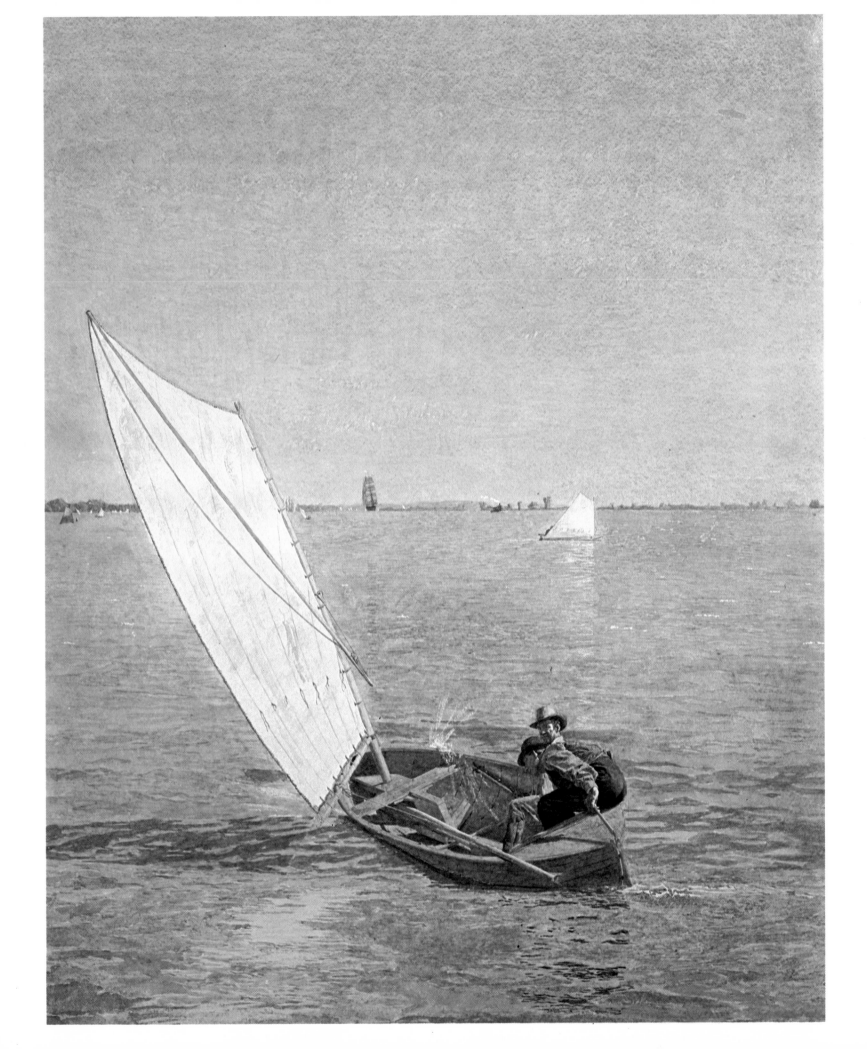

Plate 5
STARTING OUT AFTER RAIL
Detail of Plate 4, Actual Size

Plate 6
BASEBALL PLAYERS PRACTICING
1875
9⅜" x 10½" (23.8 cm. x 26.6 cm.)
Museum of Art, Rhode Island School of Design

In his letter of January, 1875, to his friend Shinn, Eakins commented further on his watercolors. About the baseball players practicing, he wrote: "The moment is just after the batter has taken his bat, before the ball leaves the pitcher's hand. They are portraits of athletic boys, a Philadelphia club. I can see that they are pretty well drawn. Ball players are very fine in their build. They are the same stuff as bullfighters only bullfighters are older and a trifle stronger perhaps. I think I will try to make a baseball picture someday in oil. It will admit a fine figure painting."

Here again, Eakins employs the same device we see in Plate 1 and Plate 3: the placement of the central figures' heads near a continuous line. In the other pictures this was a horizon line, but here it is the railing in front of the bleacher seats. There is evidence that Eakins may have conceived this picture as a smaller one and then enlarged it in the process of painting. This is evident from the discontinuous color which can be noted at the left and right of the central portion of the picture. Since this work was one of those shown in the Centennial Exhibition in Philadelphia in 1876, Eakins presumably regarded it as finished in spite of its uncompleted appearance.

The source of the sunlight that illuminates the scene is low in the sky, creating the same dramatic shadows on the figures as in the Biglin watercolor (Plate 1). As in *Whistling for Plover* (Plate 3), figures are anticipating an event which takes place outside the picture. Such pictures are not discontinuous, but carry the viewer's imagination well beyond the borders of the composition.

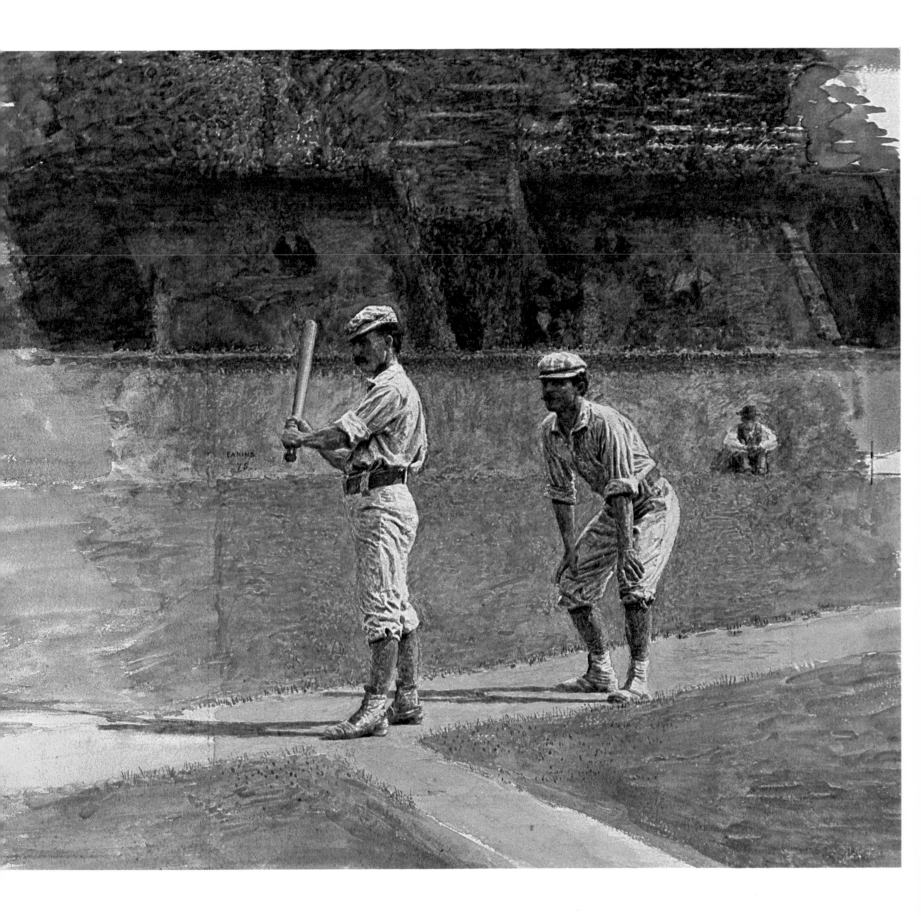

Plate 7
DRIFTING
1875
10¾″ x 16½″ (27.3 cm. x 41.9 cm.)
Collection Mr. Thomas S. Pratt

Eakins painted at least three identical compositions in oil at the same time that he made this watercolor, but the watercolor is the only one with a record of exhibition; this was the third water-color he exhibited in the American Society of Painters in Water Colors, February, 1875, in New York.

In his letter to Shinn, Eakins described it as "a drifting race." He wrote: "It is a still August morning, 11:00 o'clock. The race has started down from Tony Brown's at Gloucester [New Jersey] on the ebbtide. What wind there is from time to time is eastern and the big sails flop out some one side and some the other. You can see a least little breeze this side of the vessels at anchor. It turns up the water enough to reflect the blue sky of the zenith. The rowboats and the sailboats in the foreground are not the racers but starters and lookers on." When it was shown in 1874, the painting bore a more descriptive title: *No Wind— Race-boats Drifting.*

In the picture Eakins strives for the same diffused light and pearly tonality found in *Whistling for Plover* (Plate 3). He went on to remark to his friend Shinn that "the color was very true." This is one of the very few subjects Eakins painted as a pure landscape, without specific human references. The subject is

really light and enveloping atmosphere; its hushed, poetic mood reminds one of Whistler. The picture must have had a special place in Eakins' intentions, for according to his own records, he contributed it to a sale in 1880 for the benefit of the family of his late friend and professor at the Academy, Christian Schussele.

Figure 4. *Becalmed on the Delaware*, 1874, oil on canvas, 10⅛″ x 17¼″ (25.7 cm. x 43.8 cm.). Philadelphia Museum of Art.

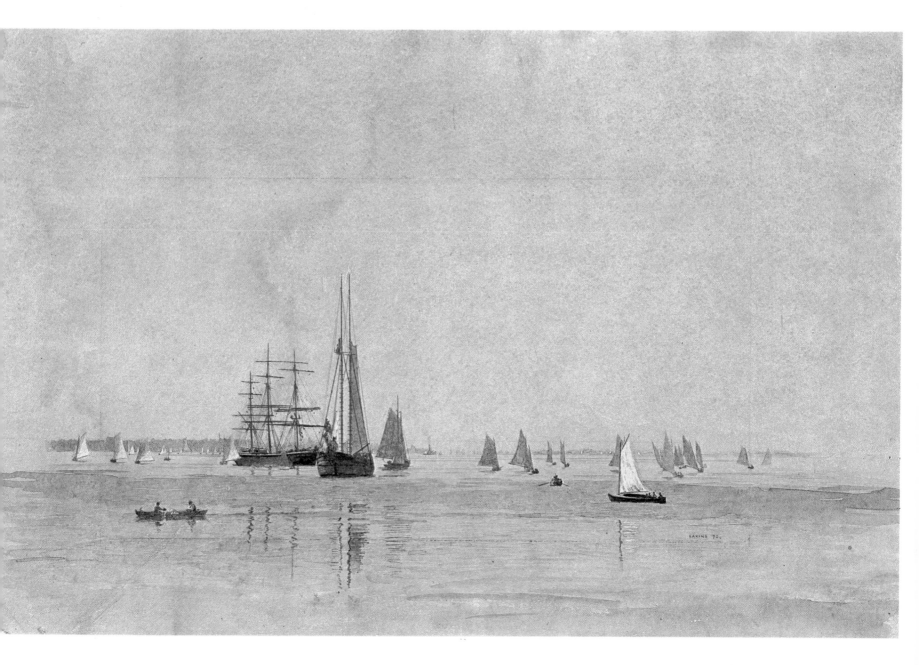

Plate 8
DRIFTING
Detail of Plate 7, Actual Size

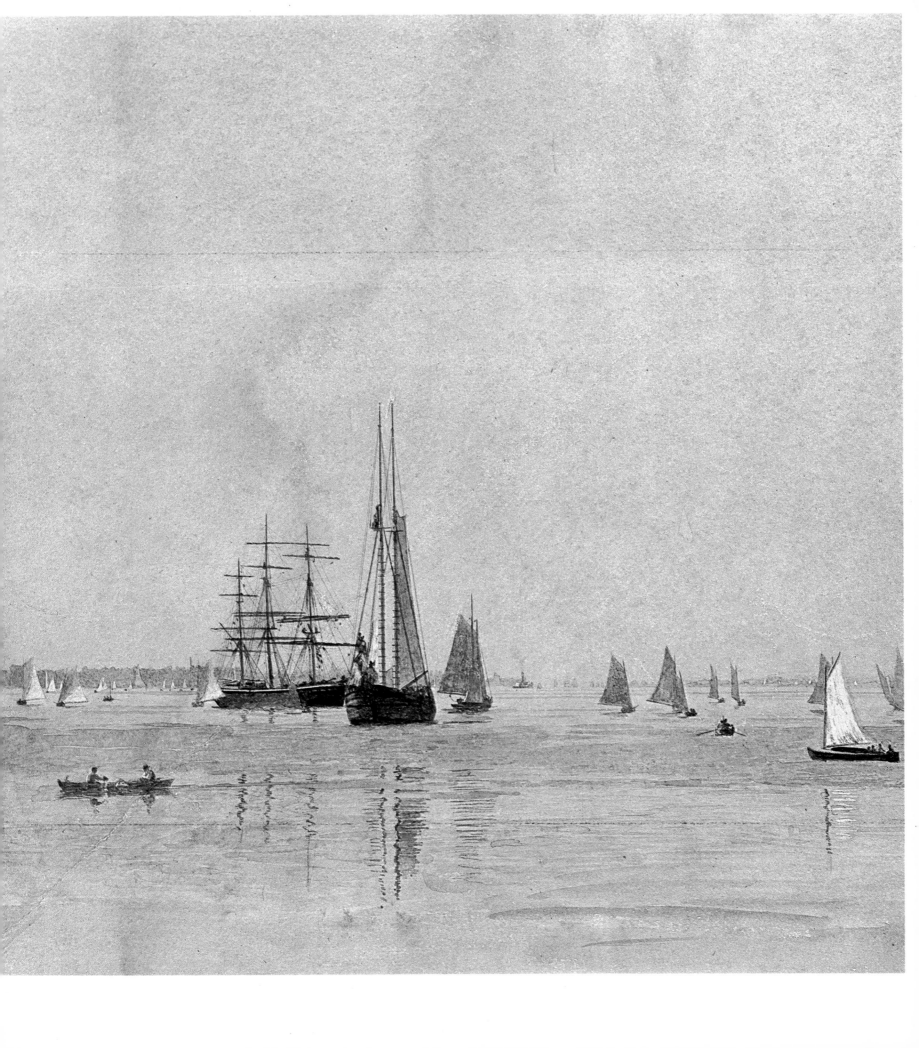

Plate 9
THE ZITHER PLAYER
1876
12⅛″ x 10½″ (30.8 cm. x 26.6 cm.)
Art Institute of Chicago

Both in subject matter and in treatment, the subject is related very closely to *The Chess Players* (Metropolitan Museum of Art), also of 1876. The two men represented in the watercolor are the artist's friends, Max Schmitt and the painter William Sartain, shown seated to the left. The room is plunged into deep shadow; toward the back is a silk hanging on the wall, partially draping over the chair in which Sartain is seated and lending a bright note of alizarin to the composition. The furniture was probably borrowed from the mixed assortment in the Eakins family parlor, a mixture of the fashionable eclectic styles. The airmchair appears to be Jacobean revival and the side chair a high Victorian Rococo revival—with an 18th century Philadelphia tilt-top table. The same table appears in *Young Girl Meditating* (Plate 11), completed the following year.

The focus of interest in *The Zither Player* is the top of the table, with its bottles and glasses, its corkscrew, its zither tuning key, and the zither itself. Beyond the midpoint of the table, the focus becomes blurred, and one is reminded of Eakins' theories about perception and his interest in photographic studies. Eakins has signed the work in a typical way, with the script letters and the date laid out in perspective on the floor.

About seven years later, Eakins painted *Professionals at Rehearsal* (Figure 5), a reworking of the zither theme. While the central elements of the table and the zither remain the same, it is clear that Eakins has rethought this composition and has injected a much more dramatic note by bringing the heads of both subjects into a stronger chiaroscuro. The figure to the left has become a participant in the scene now, rather than a spectator as he was in the watercolor version. There is the suggestion, also, that Eakins may have been recalling the genre subject matter of the 17th century Spanish masters, particularly Velasquez.

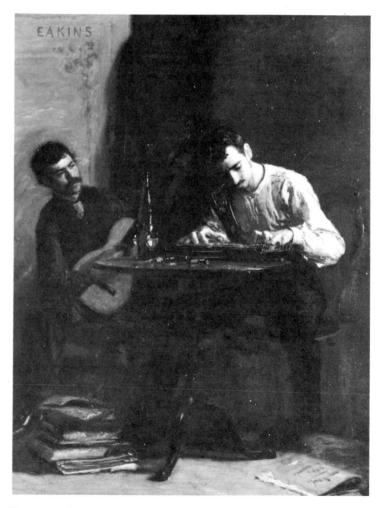

Figure 5. *Professionals at Rehearsal*, ca. 1883, oil on canvas, 16″ x 12″ (40.6 cm. x 30.4 cm.). Philadelphia Museum of Art, John D. McIlhenny Collection.

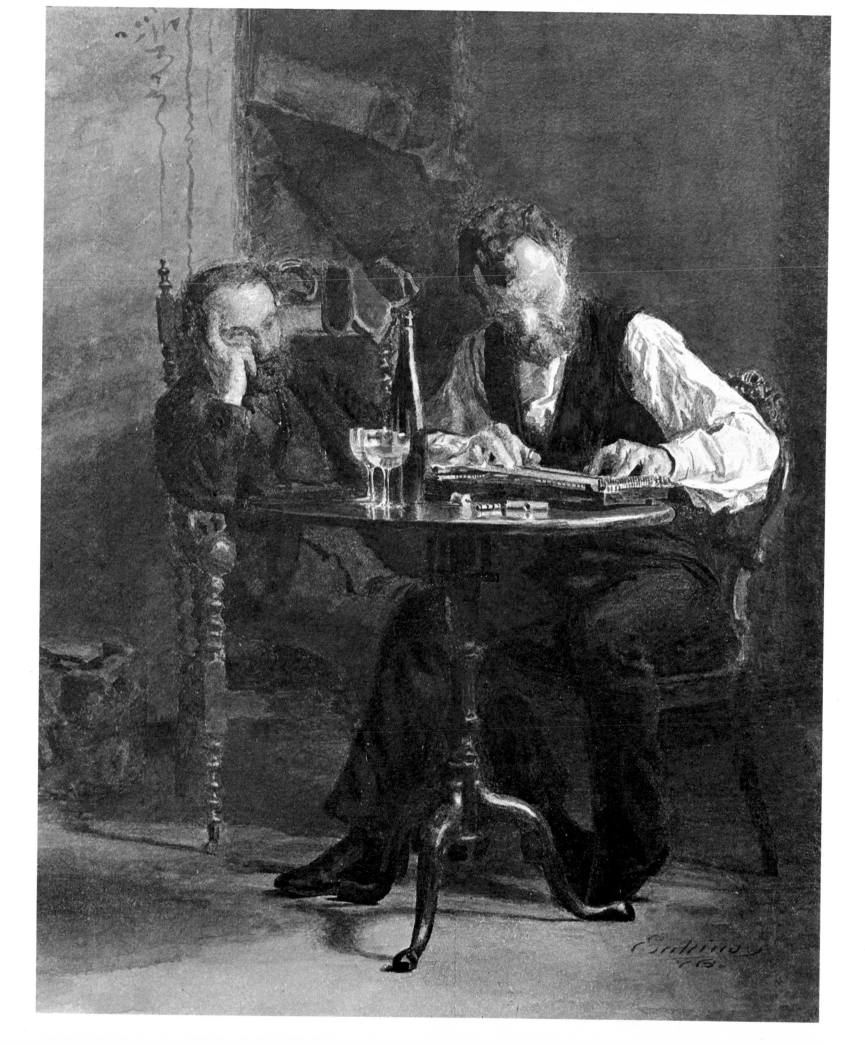

Plate 10
SEVENTY YEARS AGO
1877
15⅝″ x 11″ (39.7 cm. x 27.9 cm.)
The Art Museum, Princeton University

This watercolor, one of Eakins' most luminous and subtle color statements, appears in his work at the same time as the large oil, *William Rush Carving His Allegorical Figure of the Schuylkill River*. The subject of the watercolor, who also appears as a secondary character in the William Rush painting, is known to us only as Mrs. King. The watercolor may have been intended as a study for a portion of the large oil of the William Rush subject; however, there are significant differences between the watercolor and the portion of the oil in which Mrs. King is painted, and these suggest that the watercolor was an independent work.

The title of the watercolor clearly refers to the time of William Rush, the Philadelphia sculptor who flourished around the end of the preceding century and into the second quarter of the 1800's. Mrs. King's chair is a high style Philadelphia Chippendale side chair; to the left is an 18th century spinning wheel, while to the right may be seen a tilt-top table, perhaps the same one that Eakins used in *The Zither Player* (Plate 9). The simple, yet highly effective color composition of the picture is notable for its subtle use of pale blues and gray lavenders which are juxtaposed against umbers and dull reds. The almost impression-ist treatment of the carpet in the foreground, with its brilliant reds and blues against a tan ground, provides a very effective foil for the lustrous whites of the dress and the broad gray washes of the background.

Eakins has paid special attention to the lady's face and hands, investing them with character and dignity. Also notable is his attention to the differences in textures: the warm fleshiness of the hands and face, the glistening softness of the veil and hair, the smooth folds of the dress, and the burnished, cresting rail of the chair. Eakins also used the subject of the old lady knitting in a sculpture (dating from 1882 or early 1883) which was commissioned as a chimney piece decoration for a house in Philadelphia. Eakins' use of historical costume and furniture in his work—with a deliberately nostalgic title—is not the only instance of a return to the colonial past for subject matter. Between 1878 and 1881, he painted some dozen subjects in oil and watercolor which are deliberate evocations of the mood of early 19th century American genre painting. The Centennial Exhibition of 1876, which revived many furniture styles of the late 18th and early 19th centuries, may very well have inspired and provided material for this look into the past.

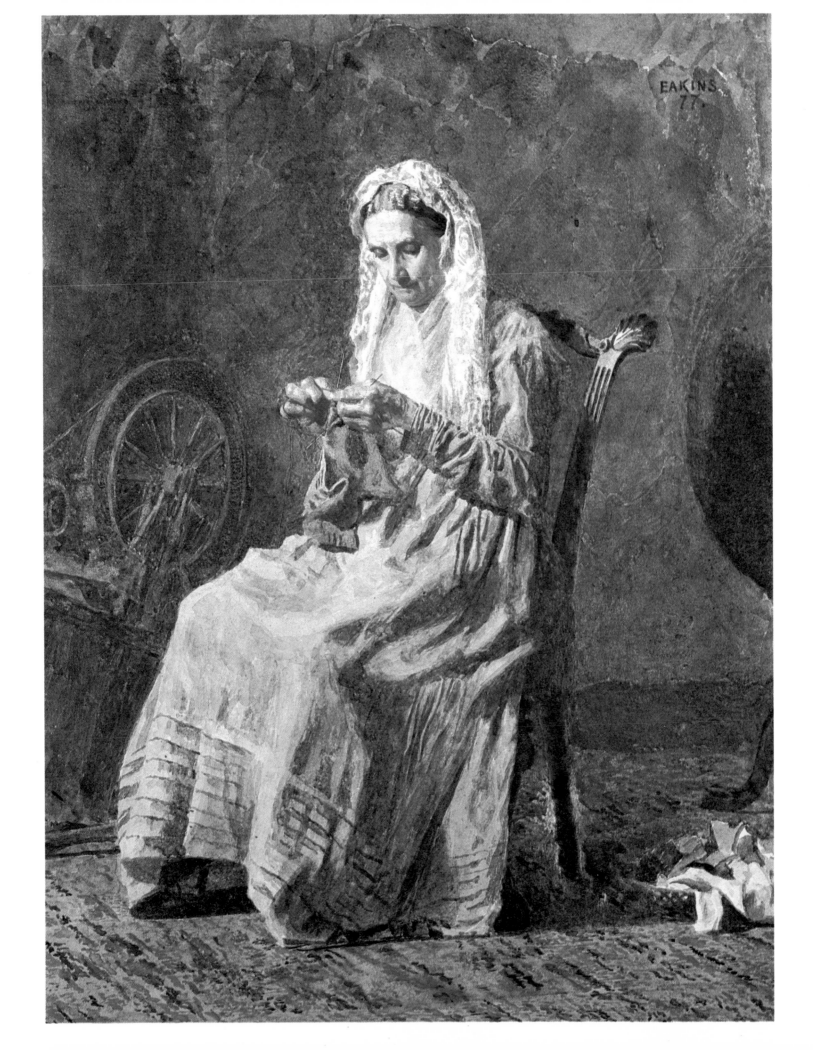

Plate 11
YOUNG GIRL MEDITATING
1877
8¾" x 5½" (22.2 cm. x 13.9 cm.)
The Metropolitan Museum of Art, Fletcher Fund, 1925

It is a singular fact that Eakins, as an artist, had no interest in the industrialized society which was growing up around him in Philadelphia. Many of his pictures from this post Civil War period seem to look backward in time, toward a more agrarian age. Eakins did not retreat overtly into the past, but simply turned his eyes to scenes which pleased him. The subjects which he chose to paint on the rivers around Philadelphia or in the New Jersey marshes include no hint of the industrialism that was growing in the Delaware River Valley. Eakins led a quiet, contemplative existence, perhaps reinforced in his isolation by the fiasco of *The Gross Clinic* and the bitter criticism of his art which followed the exhibition of the picture in 1876.

Both in its small size and in its intensely introspective mood, this little interior—with its solemn figure dressed in an old-fashioned yellow silk dress—is an intensely personal statement. The watercolor bore other titles, given it by Eakins, such as *Fifty Years Ago* and *A Young Lady Admiring a Plant*. Eakins has been criticized for retreating from the world which met his *Gross Clinic* with such hostility; it has been pointed out that such work as this watercolor does not truly represent him as an artist. Perhaps this picture, like some of the other small watercolors, does appeal to a more genteel sensibility than Eakins was accustomed to address. But there is undeniable charm in this small figure of one of his pupils, and in spite of the self-conscious arrangement of studio props, Eakins achieved an undeniably poetic statement concerning light and color.

This charming emissary was sent to an exhibition in Boston in 1878, where it was awarded the silver medal under the unlikely auspices of the Massachusetts Charitable Mechanics Association Exhibition.

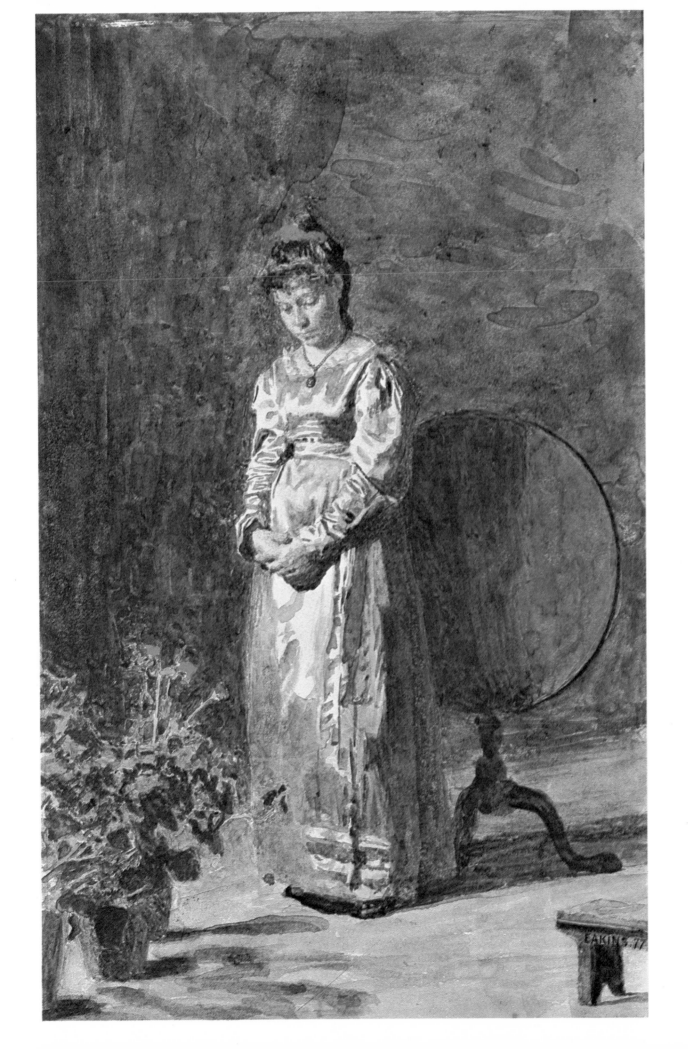

Plate 12
NEGRO BOY DANCING
1878
18⅛″ x 22⅝″ (46 cm. x 57.5 cm.)
The Metropolitan Museum of Art, Fletcher Fund, 1925

The 19th century white American painter usually portrayed the black man as a happy, singing, carefree stereotype. Even the most sympathetic portraits by an artist such as William Sidney Mount (1807-1868) reveal a patronizing attitude toward the subject. Eakins, with his insistent need for truthful representation about life, looked for those particular qualities in men, black and white, that revealed their individuality. One of America's important black artists, Henry O. Tanner (1859-1937), had been a pupil of Eakins at the Pennsylvania Academy. Eakins painted a very moving portrait of Tanner around 1900, in which he mirrored his friend's frustrations and deep personal struggles.

Nothing is known of the identities of the three persons represented in this watercolor. However, the wooden bench to the right, which appears in other pictures by Eakins, indicates that this scene may have been posed in the studio on Mt. Vernon Street. Its three protagonists symbolize three ages of man: childhood, early manhood, and old age. Both in the way the figures are posed and in their facial expressions, one can read different states of consciousness. The child with his chubby face and buoyant energy, dancing artlessly and intuitively to the rhythm of the banjo; the banjo player himself, seated easily and assuredly on the chair, bending rhythmically in time with his own music; the old man keeping time to that music with his foot and leaning on the chair, while he gazes down fondly at the child—they are all closely bound by strong cultural and personal ties. This is a mystical circle, a continuity of life which never ceases. Above them to the left, Eakins has included a small portrait of Abraham Lincoln and his son in an oval frame hanging on the wall. This is a gratuitous and hardly necessary element in the composition, although it is a visual reminder that the subjects of the picture are free men.

Again, Eakins worked from the large oil sketch toward the smaller, finished watercolor. The boy dancing and the banjo player seem quite independent from one another in feeling. Eakins may have observed and sketched them separately, joining the two together in a composition at a later time.

44

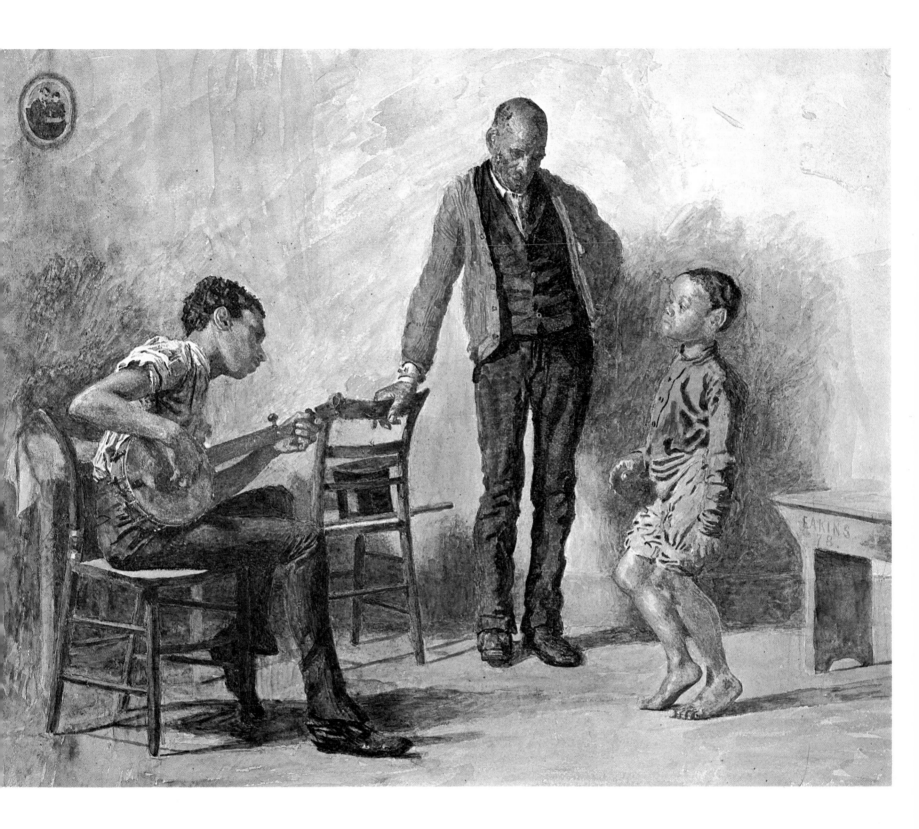

Plate 13
BANJO PLAYER FROM NEGRO BOY DANCING
Detail of Plate 12, Actual Size

Figure 6. *The Banjo Player*, 1878, oil on canvas, 19″ x 14⅜″ (48.2 cm. x 36.5 cm.). Collection Mr. and Mrs. Paul Mellon.

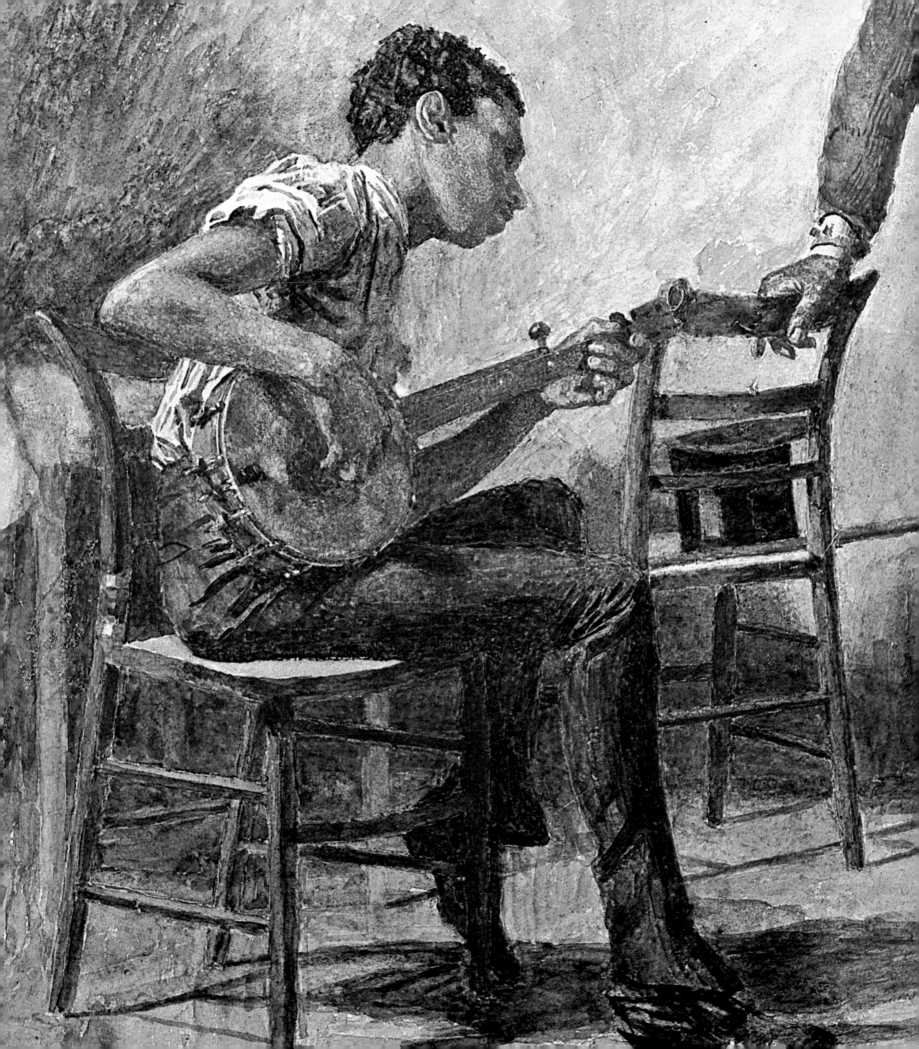

Plate 14
NEGRO BOY DANCING
Detail of Plate 12, Actual Size

Figure 7. *Study for Negro Boy Dancing*, 1878, oil on canvas, 21″ x 9″ (53.3 cm. x 22.8 cm.). Collection Mr. and Mrs. Paul Mellon.

Plate 15
FEMALE NUDE
Early 1880's
17" x 9"; image 11" x 3½" (43.2 x 22.8 cm.; image 27.9 x 8.9 cm.)
Philadelphia Museum of Art

As a student in Paris, Eakins had seen the exhibitions of the official Salon and observed how the French painters (so acclaimed by the public taste of the day) painted nudes. Probably in 1867, he wrote to his father: "I send by mail a catalog of the Exhibition of Fine Arts. The great painters don't care to exhibit there at all; about twenty pictures in the whole lot interest me. The rest of the pictures are of naked women, standing, sitting, lying down, flying, dancing, doing nothing, which they call Phrynes, Venuses, Nymphs, Hermaphrodites, Houris, and Greek proper names. The French court has become very decent since Eugénie had fig leaves put on all of the naked statues in the Garden of the Tuileries. When a man paints a naked woman he gives her less than poor Nature did. I can conceive of few circumstances wherein I would have to paint a woman naked, but if I did I would not mutilate her for double the money. She is the most beautiful thing there is—except a naked man, but I never yet saw a study of one exhibited. It would be a godsend to see a fine man painted in the studio with bare walls, alongside the smiling, smirking goddesses of many complexions, amidst the delicious arsenic green trees and gentle wax flowers and pearling streams a'running up and down the hills, especially up: I hate affectation."

His hatred of affectation extended into his art long after his student days were over. When he returned to the Pennsylvania Academy in Philadelphia in 1876, this time to teach, Eakins gave greater emphasis to figure painting than had ever been known at the Academy before his time. But outside the studio classes, there were few "circumstances" in which Eakins could paint the nude human figure. A year later, in 1877, Eakins invented such a circumstance in *William Rush Carving His Allegorical Figure of the Schuylkill River*. The painting is an elaborate theatrical setting for the nude figure, although the picture does not represent a historical fact. William Rush actually carved from a clothed figure, but Eakins invented the situation in order to provide an excuse for painting a nude. And excuses were necessary if he were to exhibit the painting publicly, for the public had been conditioned to accept the idea of the nude in painting only when it was disguised in the form of allegory or mythology. The idea of representing a realistic nude—a palpable, objective statement of the truth—would have earned Eakins the same

Figure 8. *Study for Female Nude*, 1882, oil on canvas, 24¼" x 14½" (61.6 cm. x 36.8 cm.). Collection Mrs. and Mrs. C. Humbert Tinsman.

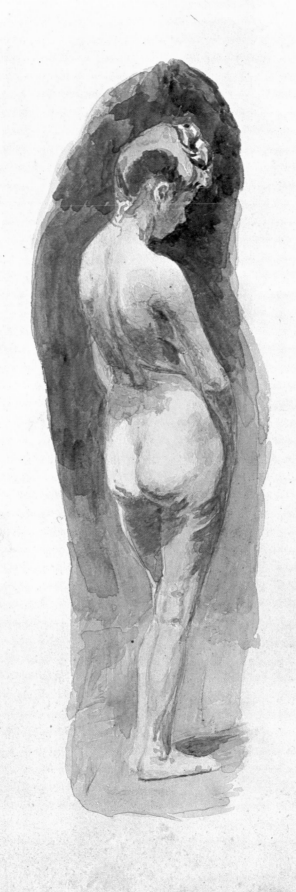

Unfinished Water Color
J. Jenkins

Plate 16
FEMALE NUDE
Detail of Plate 15, Actual Size

kind of hostility as he received for his realistic statement of a surgical operation in *The Gross Clinic*.

There are at least three studies in oil for *Female Nude*, one of them illustrated in Figure 8. The figure has the same general posture as the nude in the William Rush subject, but the quality of the raking light, which comes from directly above the figure, is different. These studies suggest a studio pose, and are much more objective, tending toward a literal statement in contrast with the more idealized one found in the William Rush painting.

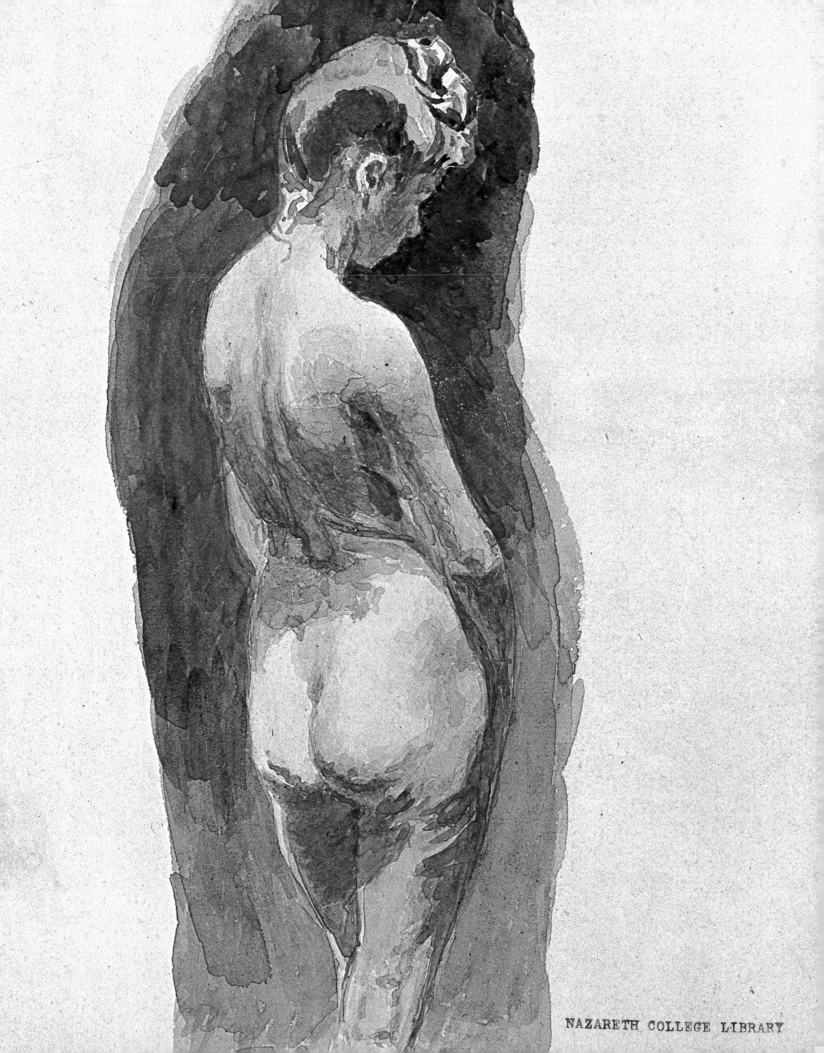

Plate 17
RETROSPECTION
ca. 1880
14⅝″ x 10⅝″ (37.1 cm. x 27 cm.)
Philadelphia Museum of Art

The subject of this study is known only as Mrs. Perkins, and the circumstances of the picture are unknown. The composition is one of Eakins' most somber; the subject is shown in a mood of dejection, with folded hands, head slightly bowed, and the face in shadow. Eakins has dressed the subject in an Empire gown and posed her in the same 18th century Chippendale that he used for *Seventy Years Ago* (Plate 10). It is another example of Eakins' interest in the past, and an attempt to make a statement about his feelings of nostalgia for that time. About 1885, a year after he married Susan Macdowell, he painted her in nearly an identical pose; except for minor details, the 1885 portrait is a reworking of the *Retrospection* theme.

This watercolor version of *Retrospection* was painted after the oil (Figure 9). The canvas and the paper are nearly identical in size, but Eakins has reduced the figure in the watercolor. The relationship of the figure to the area of the composition seems more comfortable in the oil. Note the discrepancies in the technique used in the watercolor, particularly in the background, where broad washes are employed on the left, while on the right the color appears to have been applied with mechanical, horizontal strokes. The general effect of dark interior space, too, appears to be more suitable to the oil technique. The treatment of the figure especially seems to have been a problem for Eakins. In the watercolor, only the details which are modeled from light to dark are realized with any degree of success. Eakins seems to have concentrated on the side of the girl's head, the folds of the puffed sleeves, and the shell motif on the cresting rail of the chair. Having done with the most interesting details, perhaps Eakins realized that he had reduced the size of the figure too much, and that it no longer related satisfactorily to the composition he originally intended.

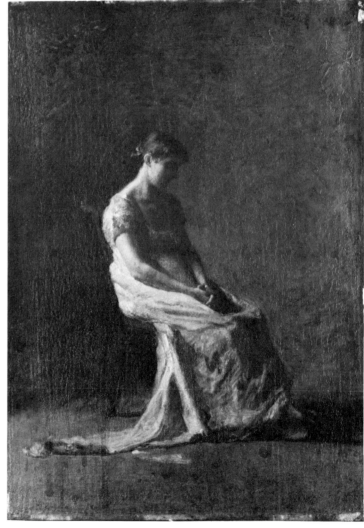

Figure 9. *Retrospection*, 1880, oil on canvas, 14½″ x 10⅛″ (36.8 cm. x 25.7 cm.). Yale University Art Gallery.

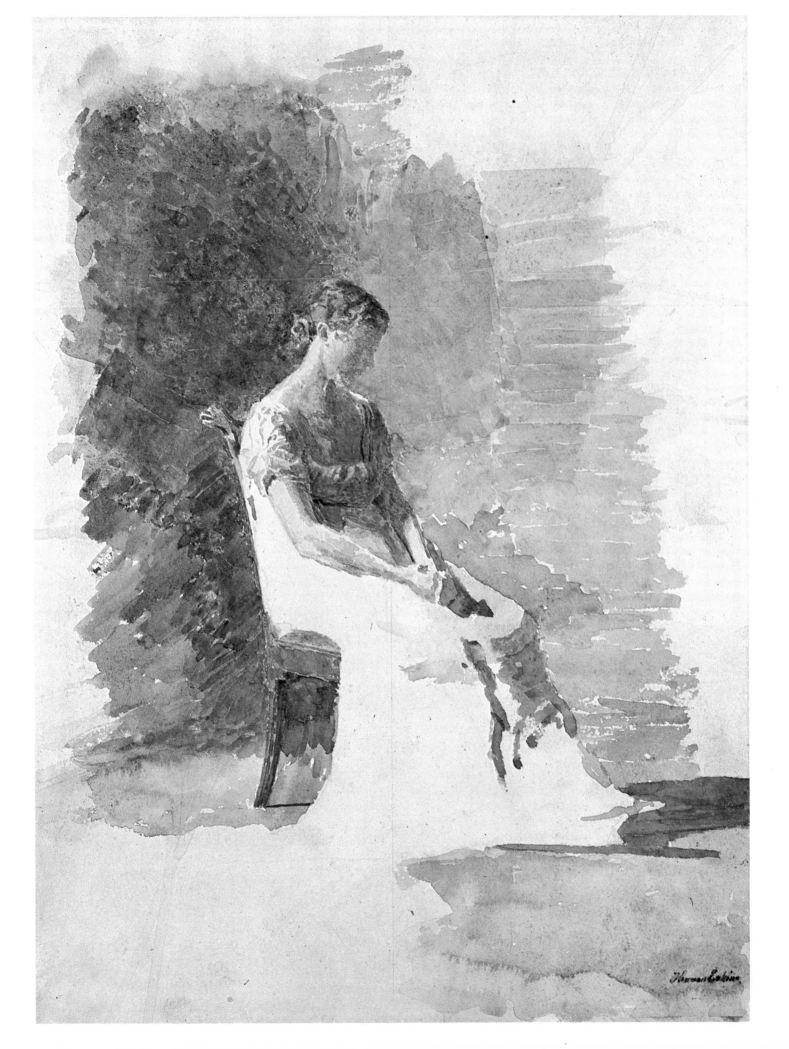

Plate 18
RETROSPECTION
Detail of Plate 17, Actual Size

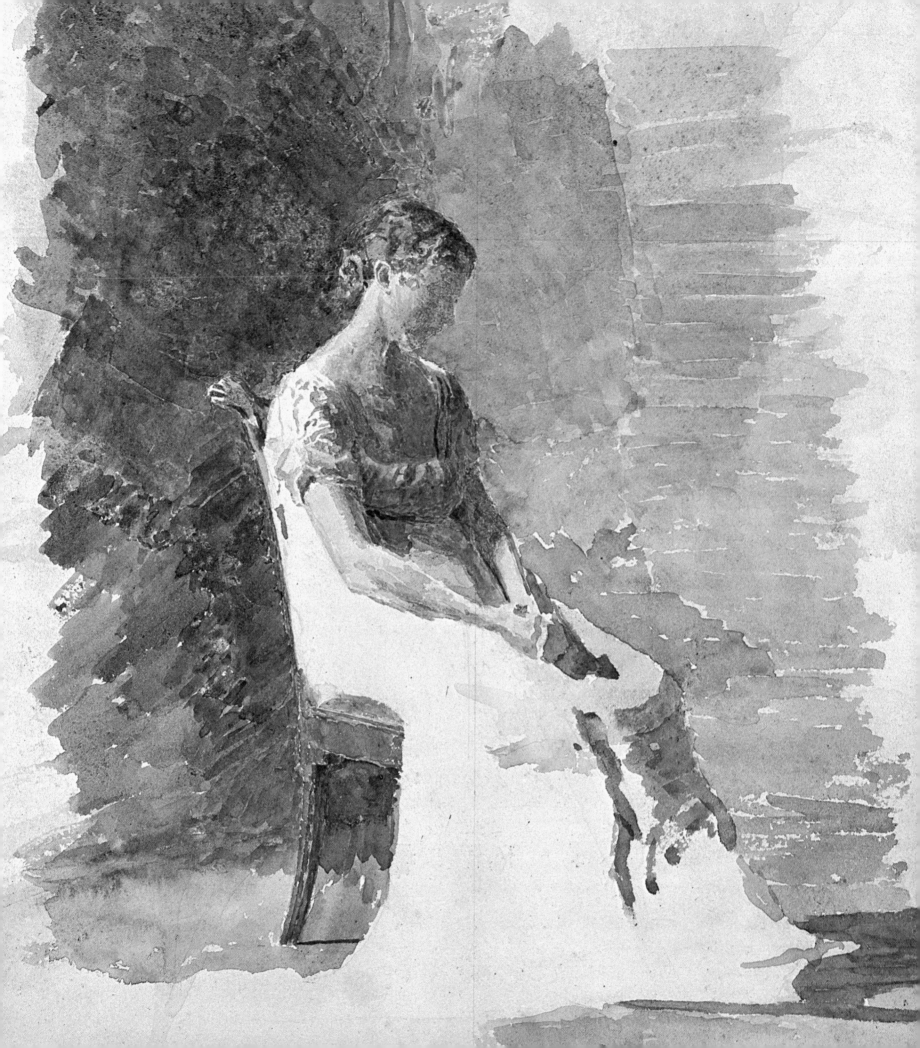

When Eakins returned from Paris in the spring of 1870, his happiness at the reunion with his family was evident in the number of portraits he painted of them. With the exception of *Max Schmitt in a Single Scull* and one imaginary subject, his family was the exclusive source of his inspiration until 1872. Of his three sisters—Frances, Margaret, and Caroline—the favorite was his middle sister, Margaret, who appears in *Spinning*. She frequently posed for him until her untimely death in 1882, a year after the creation of this watercolor. Two of Eakins' most affecting and accomplished genre scenes, *At The Piano* (University Art Museum, University of Texas) and *Home Scene* (The Brooklyn Museum), center on portraits of Margaret, seated or standing by the piano in the family parlor on Mt. Vernon Street. They are sympathetic but forthright portraits, describing her not too pretty, flat face with feeling and power.

The period of the mid-70's was one of enormous productive activity for Eakins. He spent it largely outside his Mt. Vernon Street studio, painting scenes of rowing on the rivers, shooting birds in the New Jersey marshes, and racing sailboats on the Delaware River. The chronology suggests that Eakins tended to return to interior scenes after the unpleasant incident with *The Gross Clinic*. Between 1876 and 1881, he painted only two landscapes and one other outdoor scene, *The Fairman Rogers Four-in-Hand*. The balance of his work was made up of portraiture and figure studies representing his nostalgic interest in the past. Also from this troubled period of his life came *The Crucifixion* (Philadelphia Museum of Art), painted a year after the death of his fiancée, Katherine Crowell. But by 1881, the date of *Spinning*, Eakins had met his future wife, Susan Macdowell, and his mood was changing.

This watercolor was the first subject that Eakins painted following the completion of *The Crucifixion*. Margaret posed for him in the same Empire gown he used in painting *Retrospection* (Plate 11). The setting is deliberately antiquarian; in the background, an open cabinet displays various objects, including a monteith and a shelf containing Canton ware. Margaret works at the same spinning wheel that appeared in *Seventy Years Ago* (Plate 10), seated on a turned wooden stool painted a bright viridian green. As her foot works the treadle of the spinning wheel, Eakins has represented the wheel in motion, its spokes blurred. The focal point of the composition seems to be Margaret's head, especially her ear, which is seen to glow as the light strikes it and partially passes through. The strong pattern of light and shadow clearly defines the direction of the light.

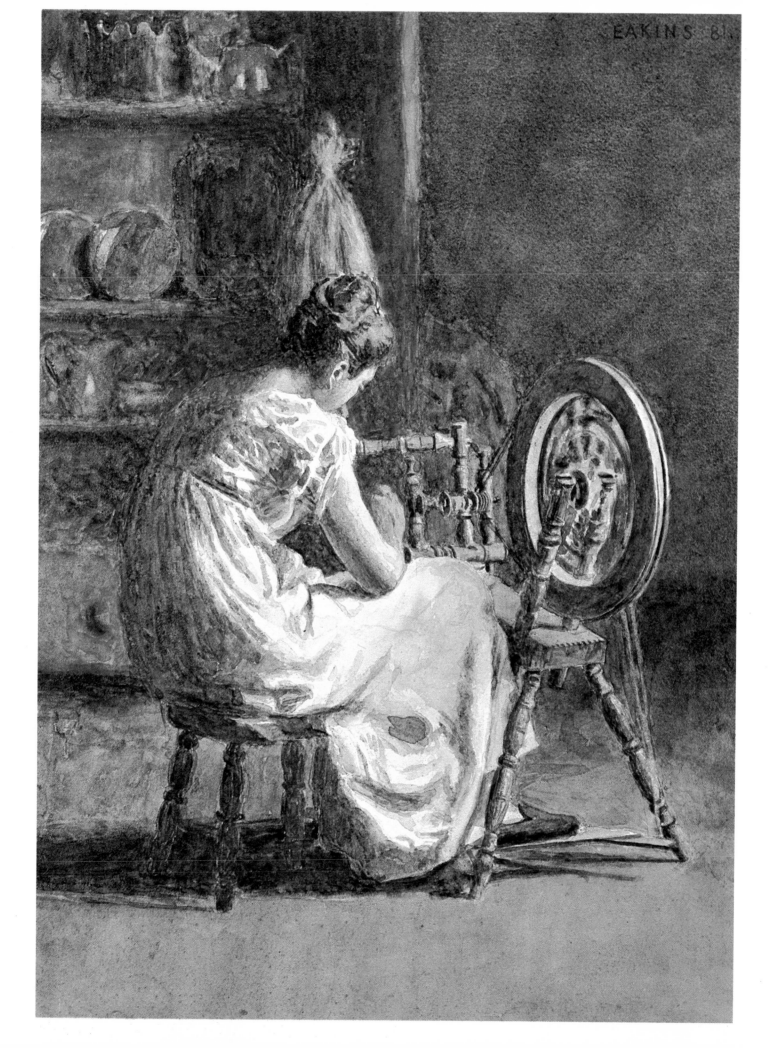

Plate 20
SPINNING
Detail of Plate 19, Actual Size

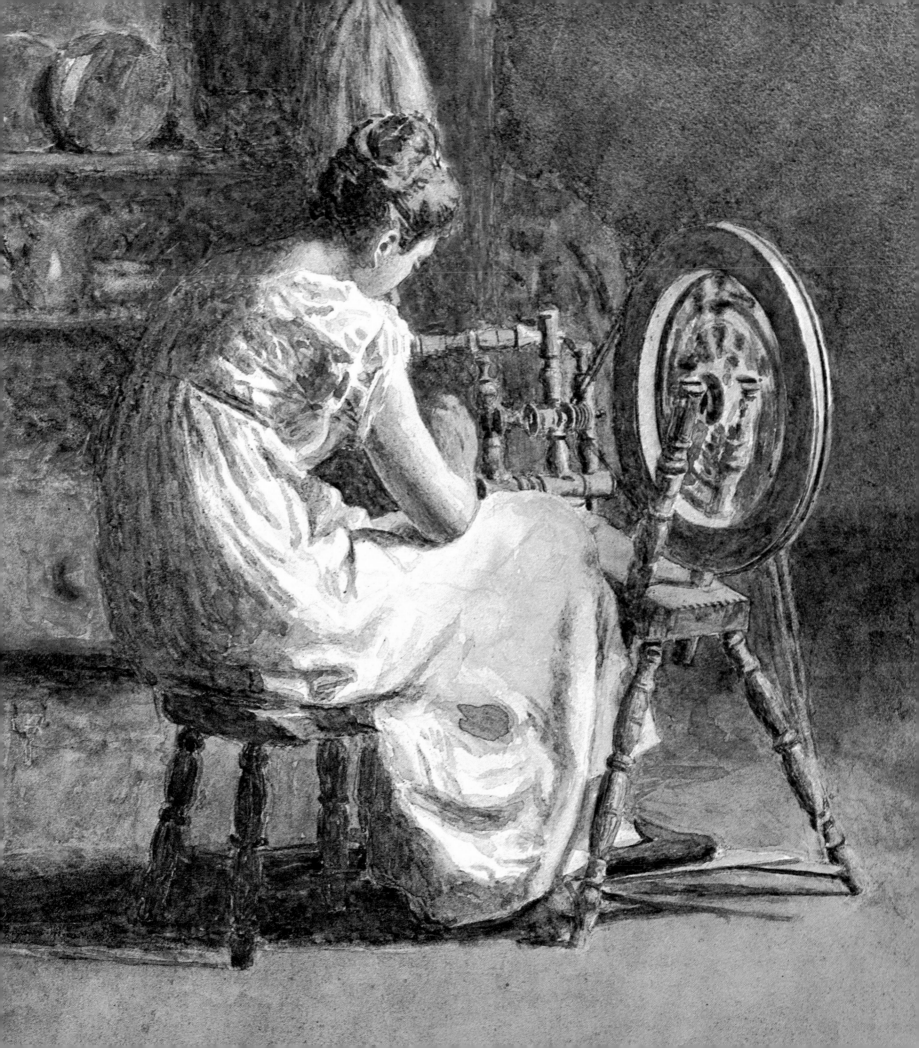

Plate 21
SPINNING
1881
11″ x 8″ (27.9 cm. x 20.3 cm.)
Collection Mrs. John Randolph Garrett, Sr.

This watercolor, a variation of the preceding plate and painted the same year, may have been created shortly before or after the other example.

Eakins thought out his various compositions in sculptural terms to understand more fully the volume of any given subject. In fact, the spinning subject was intended to be a bas-relief plaque. In 1882, he was commissioned by a Philadelphia art patron, James P. Scott, to provide designs for two mantelpiece sculptures. These were to be two small, oval reliefs. One was similar in subject matter to the watercolor, *Seventy Years Ago* (Plate 10), and the second was taken from the spinning theme. Goodrich records that the architect for the house persuaded Eakins to undertake the commission; Eakins remarked that the architect "easily induced me, for the work was much to my taste." Eakins apparently had Margaret take spinning lessons in order to assure the accuracy of the picture. Evidently, Margaret's ability with the spinning wheel increased perceptibly as the pose went on. Eakins remarked in a letter to Scott: "After I had worked some weeks, the girl in learning to spin well became so much more graceful than when she had learned to spin only passably, that I tore down all my work and recommenced." Eakins had obviously translated the watercolor studies into clay. By observing Margaret in two distinctly different positions in the two watercolors, Eakins established a thorough understanding of the plasticity of form involved.

The clay models for the plaques were submitted to Scott for his approval. Eakins wrote a letter to accompany them: "Relief work . . . has always been considered the most difficult composition and the one requiring the most learning. The mere geometrical construction of the accessories in a perspective which is not projected on a single plane but in a variable third dimension is a puzzle beyond the sculptors whom I know."

There was a disagreement over the project, and the bas-relief plaques were never translated into stone, as had been envisioned.

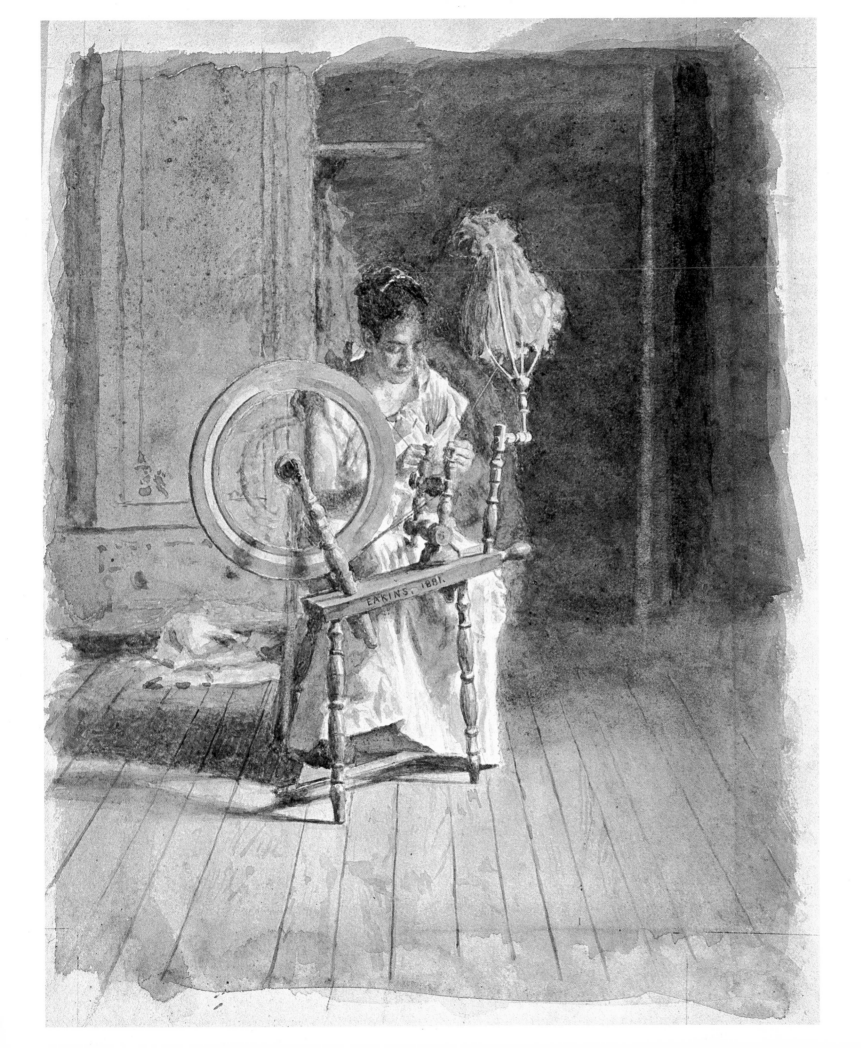

Plate 22
TAKING UP THE NET
1881
9½″ x 14⅛″ (24.1 cm. x 25.9 cm.)
The Metropolitan Museum of Art, Fletcher Fund, 1925

In the 19th century, shad were plentiful in the Delaware River. In the spring of each year, as the fish returned to their spawning grounds, commercial fishermen would cast their nets. During the spring of 1882, Eakins went to Gloucester, a small town on the New Jersey side of the Delaware river, to watch the operations. This was a family outing, for *Shad Fishing at Gloucester on the Delaware River* (Figure 10) shows the artist's father, Benjamin Eakins, as well as one sister and the family dog, Harry.

In the watercolor version, *Taking Up the Net*, the composition is narrowed to focus on the scene of the fishermen in their blue denim work shirts and colorful yellow oilskins. The watercolor strongly suggests that Eakins based this work on a photograph, rather than on actual observation of the scene itself. The poses of the fishermen are frozen in attitude, indicative of the camera's instant recording of a scene.

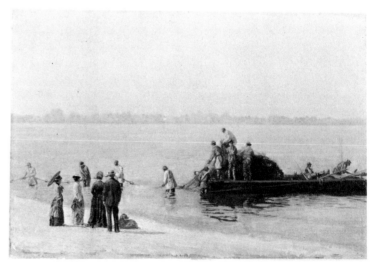

Figure 10. *Shad Fishing at Gloucester on the Delaware*, 1881, oil on canvas, 12½″ x 18¼″ (31.7 cm. x 46.3 cm.). Philadelphia Museum of Art.

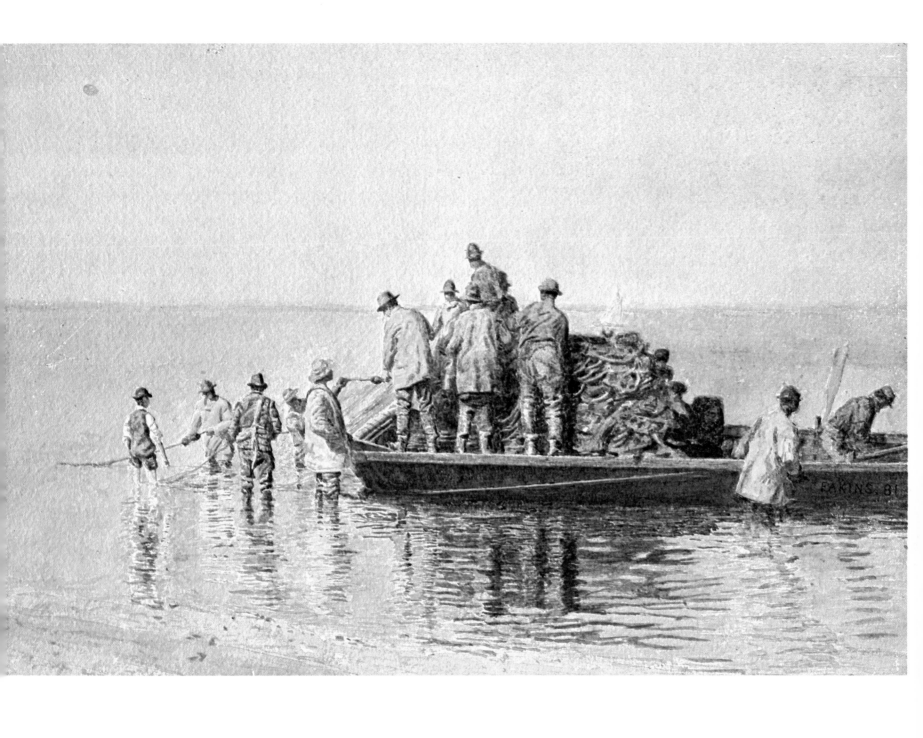

Plate 23
TAKING UP THE NET
Detail of Plate 22, Actual Size

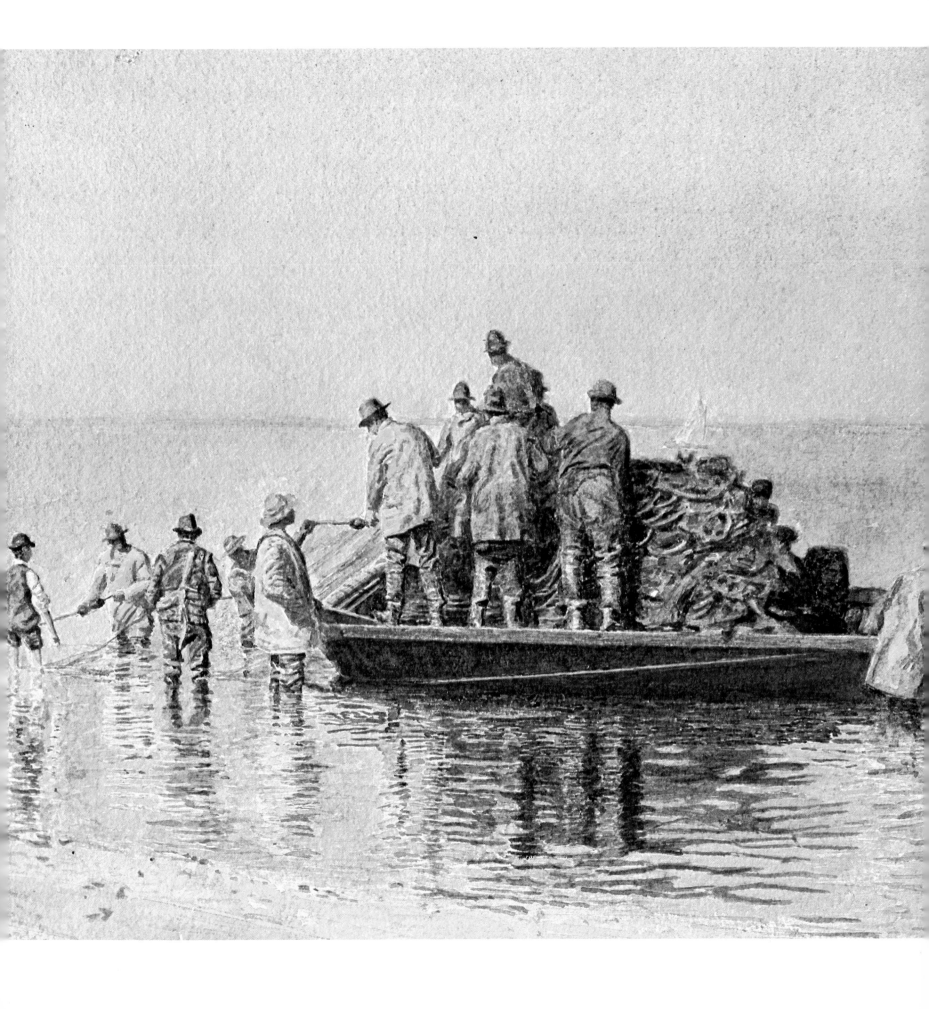

Plate 24
THE PATHETIC SONG
ca. 1881
15″ x 12″ (38.1 cm. x 30.4 cm.)
Hirschl and Adler Galleries

Eakins had been working up to the creation of this, his most successful genre painting, through that whole series of nostalgic backward looks that included *Seventy Years Ago* (Plate 10) and the *Spinning* subjects (Plates 19 and 21). *The Pathetic Song* is a culmination of all his ideas concerning the beauty and expressiveness of women in interiors. Although Eakins has distilled the essence of an affecting moment, he deals with time at hand, not the past. Again, as in so many of his pictures, he has selected a particular moment and has rendered it precisely. Eakins was fascinated by the movement of muscles in a singer's throat (eleven years later, he returned to this same subject in *The Concert Singer*) and has chosen a moment in the music when the singer has reached a sustained note, perhaps the concluding chord of the song. As she holds the note, her hands lower the score and she fixes her gaze sadly across the room. Her accompanists, the cellist and the pianist, sustain the note also, and the song comes to an end.

The principal subject in this picture was Margaret Alexina Harrison, then thirty years old and a pupil of Thomas Eakins at the Academy; her two brothers were the painters, Alexander Harrison (1853-1930) and Birge Harrison (1854-1929). The elderly man playing the cello was a Mr. Stolte, a member of the Philadelphia Orchestra. (Fifteen years later, Eakins made the subject of a man playing a cello one of his most famous works.) The woman at the piano was Susan Macdowell, then a student at the Academy under Eakins. They had met for the first time at the Haseltine Galleries in Philadelphia, where *The Gross Clinic* had been exhibited. Susan was exactly the age of Eakins' dead fiancée, and her appearance in one of Eakins' most important pictures at this time probably indicates that their romance had already begun. Three years later, in 1884, Eakins married Susan Macdowell.

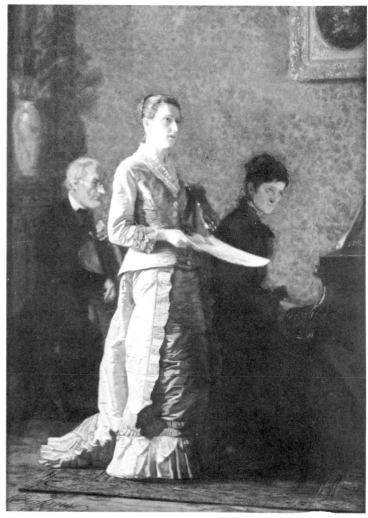

Figure 11. *The Pathetic Song*, 1881, oil on canvas, 45½″ x 32½″ (115.5 cm. x 82.5 cm.). The Corcoran Gallery of Art.

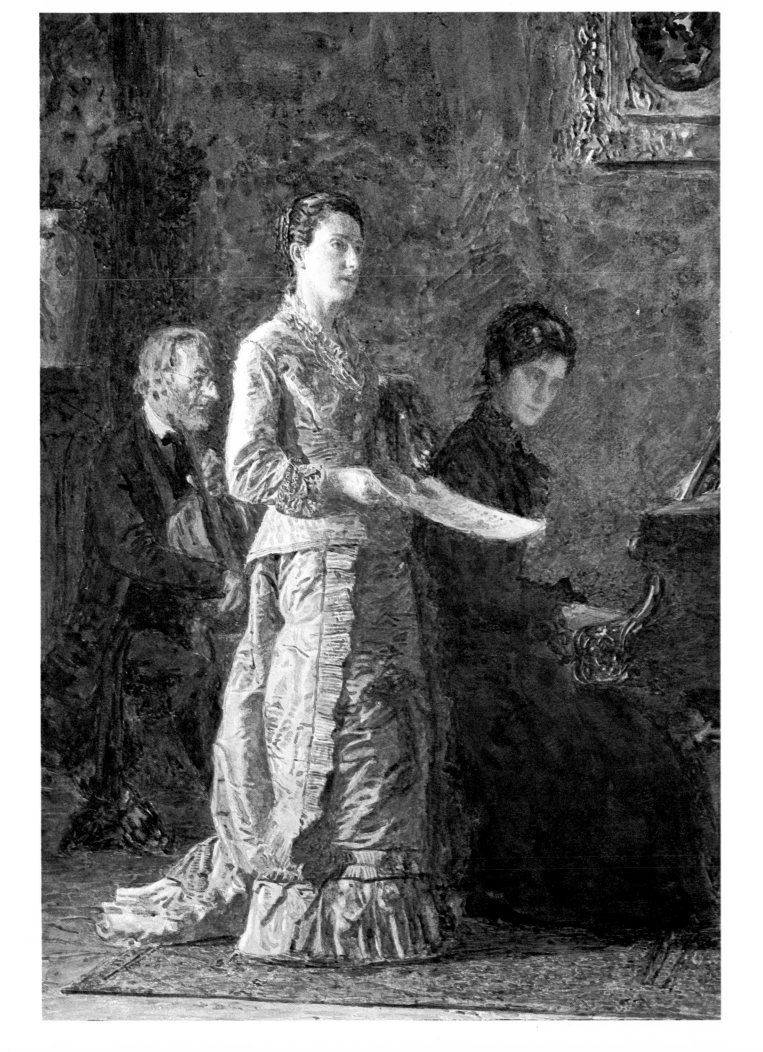

Plate 25
THE PATHETIC SONG
Detail of Plate 24, Actual Size

The watercolor version of *The Pathetic Song* was made after the oil painting (Figure 11) which Eakins gave to the principal subject, Margaret Harrison, in appreciation for her posing. While the watercolor is exactly one third the size of the oil painting, Eakins has rendered the details of the singer's dress with an undiminished power of observation. That grave and elusive color—an undefinable grayish lavender—is preserved, as is the intricately worked detail of the oriental rug in perspective on the floor. He has preserved the luminous skin tones and rendered the luminous, translucent folds of the ear with extreme care. He makes no attempt to represent the mottled effect of the wallpaper, with its sunflower motif, but simply indicates the background with umber washes. The supporting characters in the scene also receive a more cursory treatment. However, his portrait of Susan is milder and more serene in the watercolor.

Plate 26
MENDING THE NET
1882
10¾″ x 16½″ (27.3 cm. x 41.9 cm.)
Collection Mrs. George E. Buchanan

The scene is a bank of the river at Gloucester, New Jersey,
sometime during the spring of 1882. A fisherman is inspecting
his net and mending the tears, while a friend looks on. They are
in a plowed field on the banks of the Delaware, ideal for inspect-
ing a large area of net. The time of day is noon, with the sun
directly overhead, casting dramatic shadows. The sense of alone-
ness in nature is intensified by the scale of the figures in relation
to their surrounding landscape. Once more, Eakins has worked
in an almost miniaturist style, carefully delineating all the folds
of the men's clothing. The standing figure is related in attitude
to the oil, *Mending the Net* (Philadelphia Museum of Art), of
the same year, in which Eakins has posed figures of men bending
over their nets with their faces hidden from view.

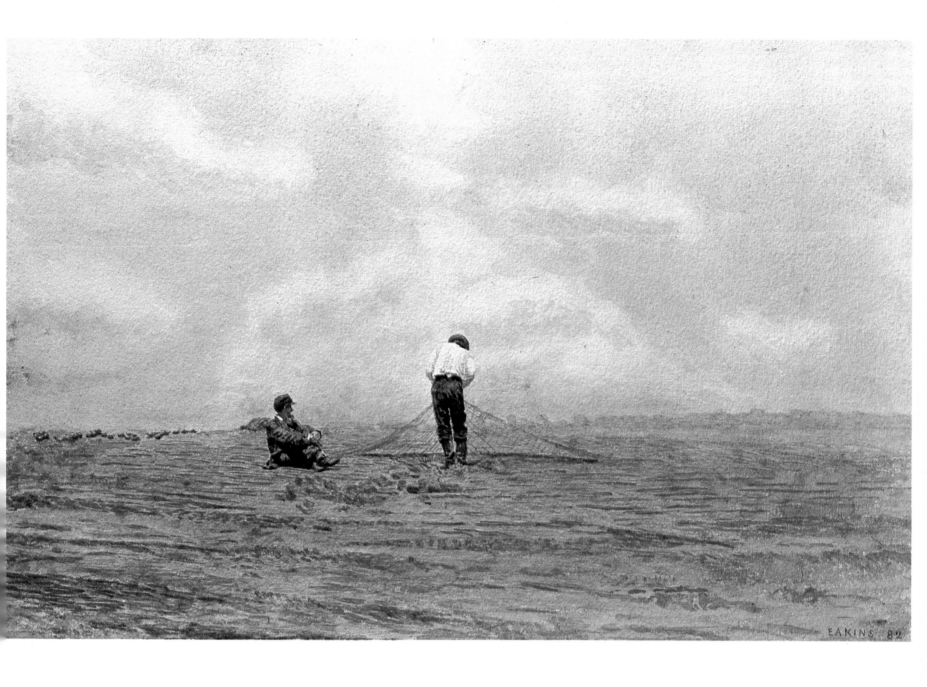

Plate 27
DRAWING THE SEINE
1882
8" x 11" (20.3 cm. x 27.9 cm.)
Philadelphia Museum of Art, John G. Johnson Collection

In *Drawing the Seine*, a smaller paper than *Mending the Net* (Plate 26), Eakins achieved a more pleasingly fluid style of painting. There is an easy handling of sky passages and peripheral detail, such as the sailboat at anchor in the river and the fishing shed to the left of the composition. This landscape, also at Gloucester, New Jersey, shows a seine being drawn from the river with a capstan turned by the fishermen with the aid of a horse. Eakins has employed a noticeably selective system of focus. The eye is led into the composition from the lower right, along the line of logs to the middle distance. However, the focus does not become sharp until halfway to that middle distance. Only the center of the composition remains consistently in focus.

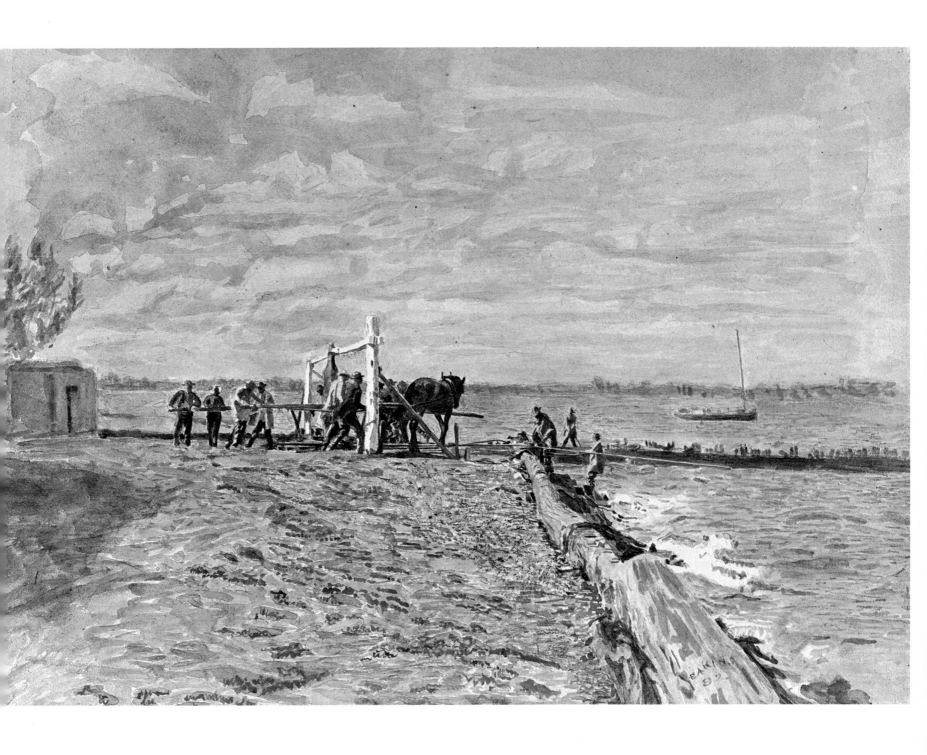

Plate 28
IN THE STUDIO
ca. 1884
21″ x 17″ (53.3 cm. x 43.2 cm.)
Philadelphia Museum of Art

The finished oil study (Figure 12) for the watercolor is dated 1884, and establishes the relationship of this composition to the portrait of Eakins' wife, *Portrait of a Lady with a Setter Dog*, painted about 1885. The similarity in costume and the use of Eakins' red setter dog, Harry—who is shown lying on the floor beside the subject of both paintings—reinforces that relationship. The identity of the girl in the composition *In the Studio* is unknown; however, it has been established that she was another of his students at the Academy. Although the watercolor version is one of Eakins' least finished works, the abstract division of the picture into nearly equal dark and light halves is visually engaging. The very subtle, but convincing notations which constitute all of the modeling in the figure do achieve a convincing shorthand for describing form. Although this subject is essentially a reworking of *Young Girl Meditating* (Plate 11) of 1877, a comparison between the two reveals Eakins' advancement in watercolor technique.

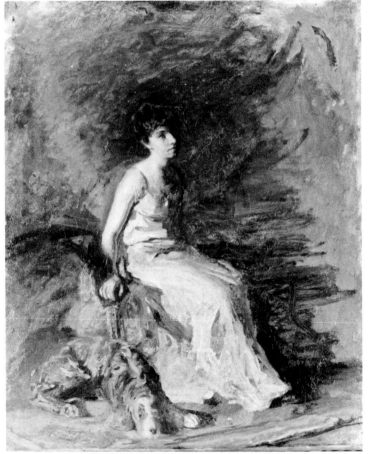

Figure 12. *In the Studio*, 1884, oil on canvas, 22¼″ x 18¼″ (56.5 cm. x 46.3 cm.). The Hyde Collection.

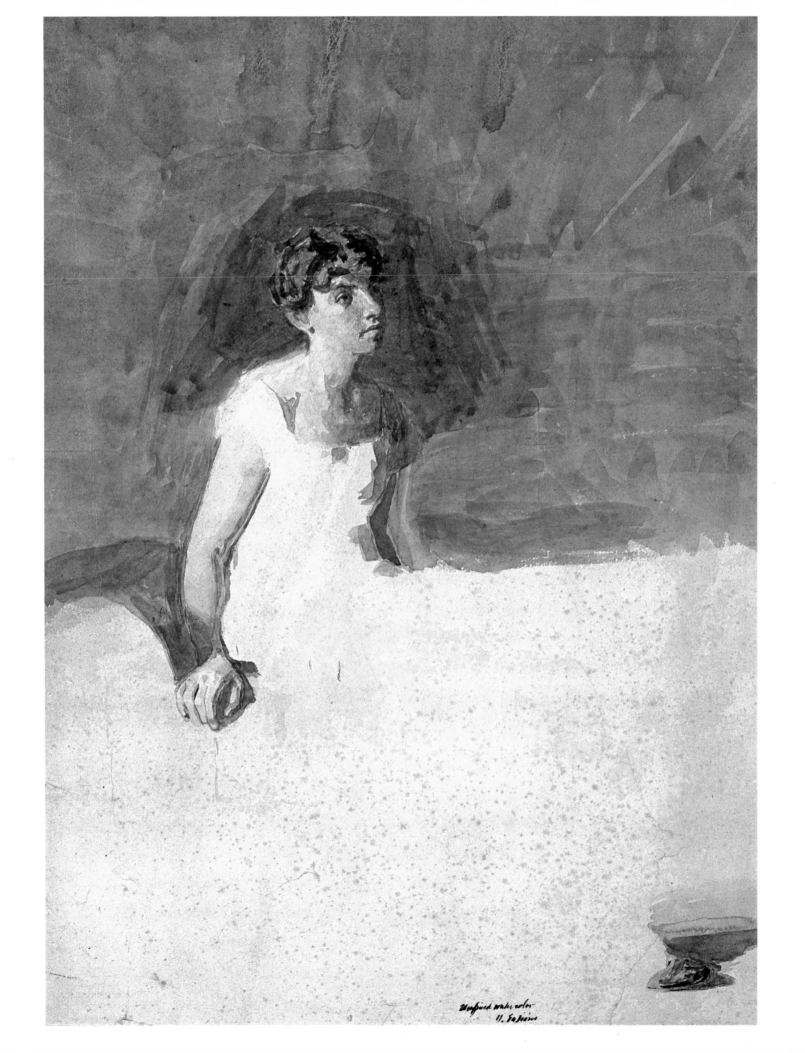

Plate 29
IN THE STUDIO
Detail of Plate 28, Actual Size

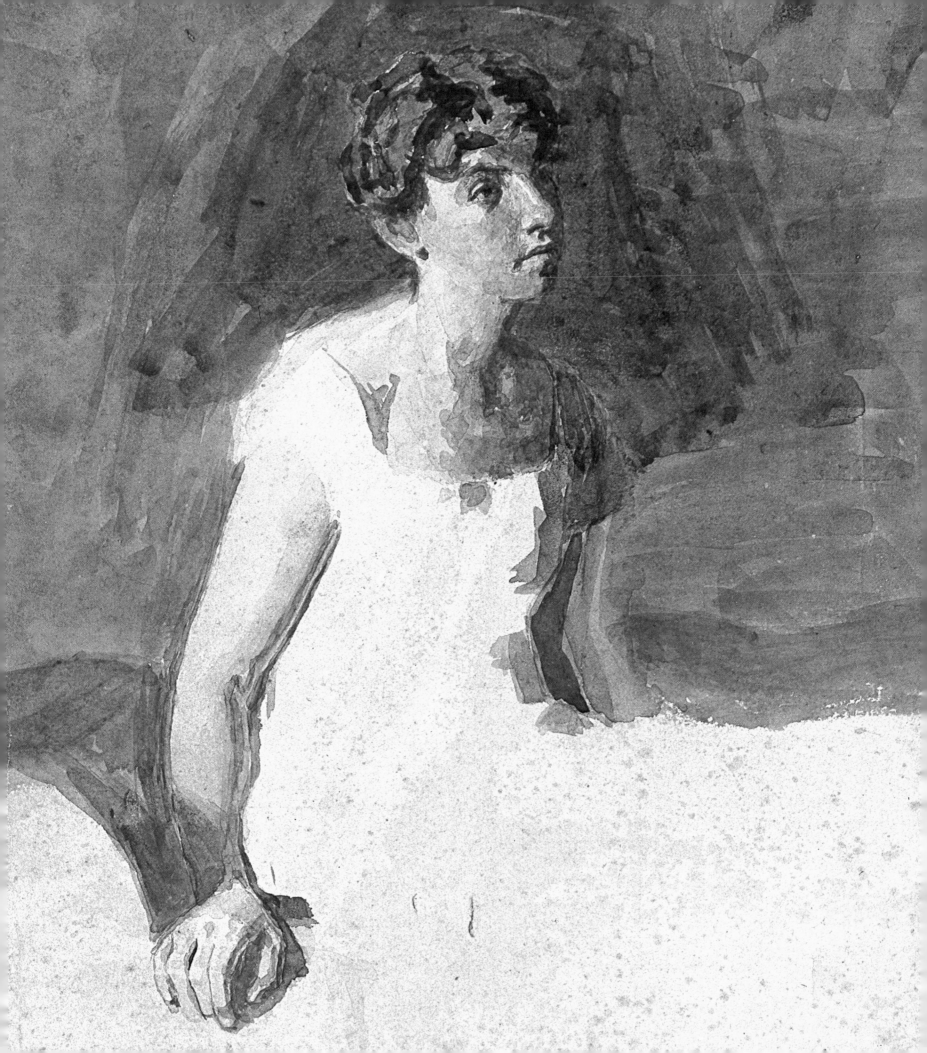

Plate 30
COWBOY SINGING
ca. 1890
18″ x 14″ (45.7 cm. x 35.5 cm.)
The Metropolitan Museum of Art, Fletcher Fund, 1925

In the summer of 1887, Eakins made a trip to North Dakota. There he discovered what was, for him, an entirely new subject: the life of the American cowboy. During his stay in the west, he worked in oil on canvas mounted on cardboard, usually on a small scale. After his return to Philadelphia in the fall of 1887, he began translating these rapid sketches, both of landscape and figure subjects, into finished works.

While he was in the west, Eakins had not only bought several suits of buckskin clothing, but had acquired two western horses as well. *Cowboy Singing* was posed in the Mt. Vernon Street studio. Eakins dressed his friend, the painter, Franklin L. Schenck (1885-1926), in a suit of buckskin. Schenck had been a pupil of Eakins at the Art Students League of Philadelphia and was its second curator. Goodrich described him as having "a poetic, unworldly temperament, he afterwards lived like a hermit on Long Island, raising all his own food and painting romantic landscapes suggestive of Blakelock. He was fond of singing and playing the guitar."

There are two oil versions of this subject, both slightly larger than the watercolor. The first version, *Home Ranch* (Philadelphia Museum of Art), appears with supporting details: behind the cowboy, who is playing a guitar, there is another man in the right background, seated at a table and holding a fork, while a black cat rubs against the table leg. This would seem to be Eakins' attempt to create a naturalistic bunkhouse scene. In the second oil version (Figure 13), Schenck also appears, but is now playing a banjo, rather than a guitar (as in *Home Ranch*), and is turned half left.

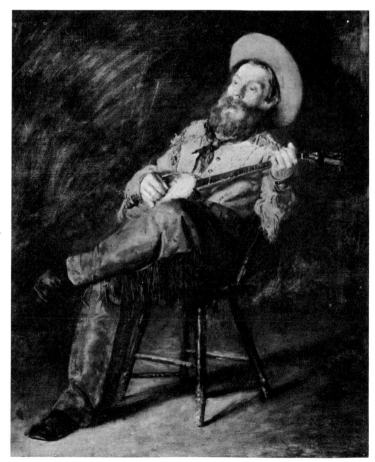

Figure 13. *Cowboy Singing*, ca. 1890, oil on canvas, 24″ x 20″ (60.9 cm. x 50.8 cm.). Philadelphia Museum of Art.

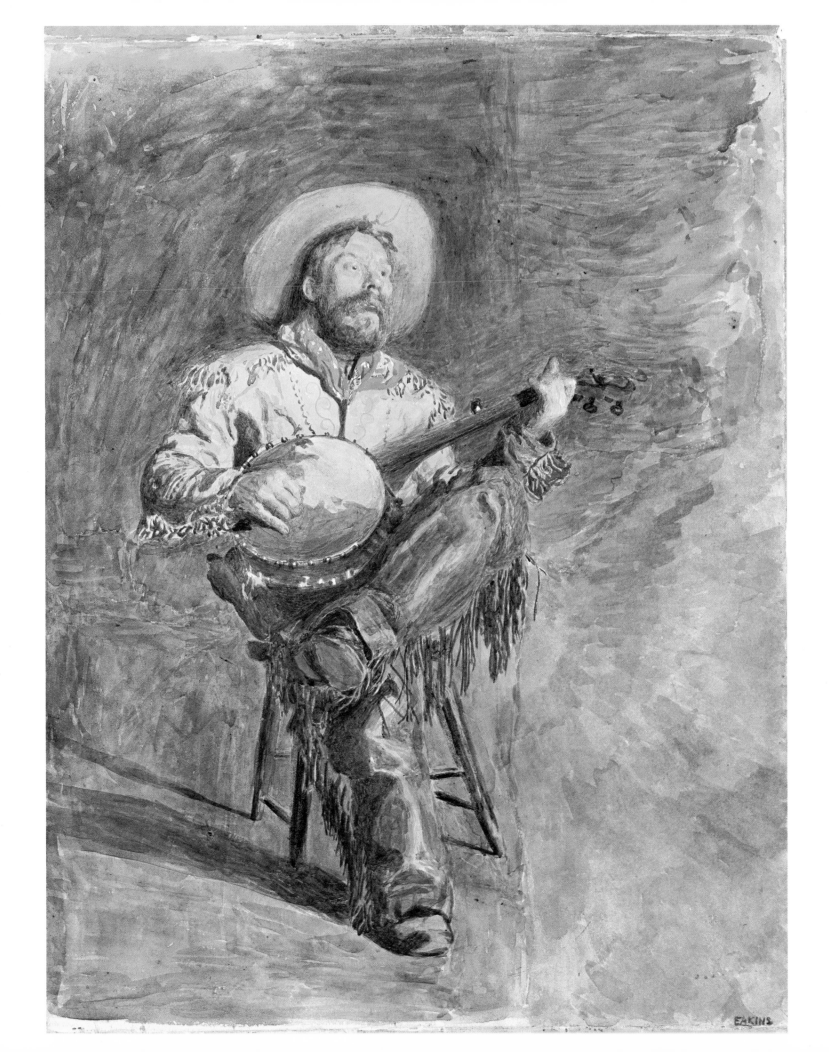

Plate 31
COWBOY SINGING
Detail of Plate 30, Actual Size

The watercolor appears somewhat unfinished, especially at the right edge of the composition, indicating perhaps that Eakins intended to finish the work in keeping with Figure 13. The watercolor contains a solitary figure who seems to be illuminated by a fire, suggesting a bunkhouse interior. While the subject matter is full of potential for a highly romantic sentimental treatment, Eakins gives us nothing of the sort. Schenck is made to appear natural in his clothes—so strange to his real personality—and the scene is entirely believable.

When *Home Ranch*, the oil painting of this subject, was submitted to the Carnegie International Exhibition in 1896, it was rejected. Today, it is difficult to understand why such a forthright and honest work would find rejection at the hands of a jury as late as 1896. Perhaps the answer is that the west had been thoroughly romanticized by artists like Frederic Remington (1861-1909), who provided an acceptable romantic mirror for a false image.

Plate 32
PORTRAIT OF WILLIAM H. MACDOWELL
ca. 1891
27″ x 21½″ (68.6 cm. x 54.6 cm.)
The Baltimore Museum of Art

When Eakins married Susan Macdowell in January, 1884, he acquired a father-in-law of unusual character, with whom he formed a lifelong friendship. Like Eakins' own father, Macdowell had been a craftsman, working in the art of engraving. On occasion, Macdowell and the elder Eakins collaborated, the former providing the engraved plate, while the latter added the engrossing to the blank spaces in the printed engraving. Macdowell was regarded as a freethinker; his favorite personality in American history was the Revolutionary writer, Thomas Paine. Macdowell was, as Goodrich remarked, "fond of new ideas and lively argument." The atmosphere of the Macdowell home in Philadelphia must have even been freer than that at the Eakins home. Susan had been reared in an environment which was, therefore, very close to the character of the Eakins home.

Over a period of about fourteen years, Eakins painted six portraits of his father-in-law. The oil study illustrated here (Figure 14) is the second of two portraits painted in 1891 in preparation for the watercolor scaled to the same size. The oil portrait is painted in a noticeably heavy impasto technique and is squared off for transfer to the watercolor paper. Eakins never completed the watercolor, and it remains a tentative exercise in his use of the medium. In both versions, the characterization of William Macdowell is penetrating and poignant. The angular face and piercing eyes which gaze out querulously, the fingers of the left hand, gnarled by years of work, comprise one of Eakins' most moving statements in the art of portraiture.

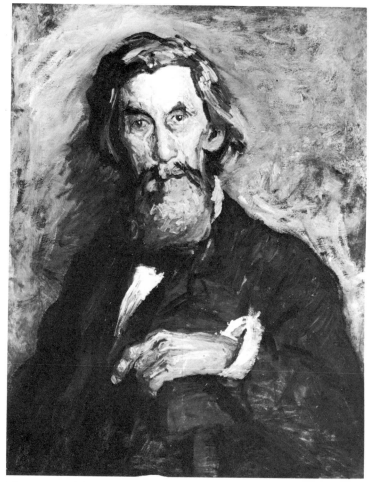

Figure 14. *Portrait of William H. Macdowell*, ca. 1891, oil on canvas, 28″ x 22″ (71.1 cm. x 55.8 cm.). Randolph-Macon Woman's College.

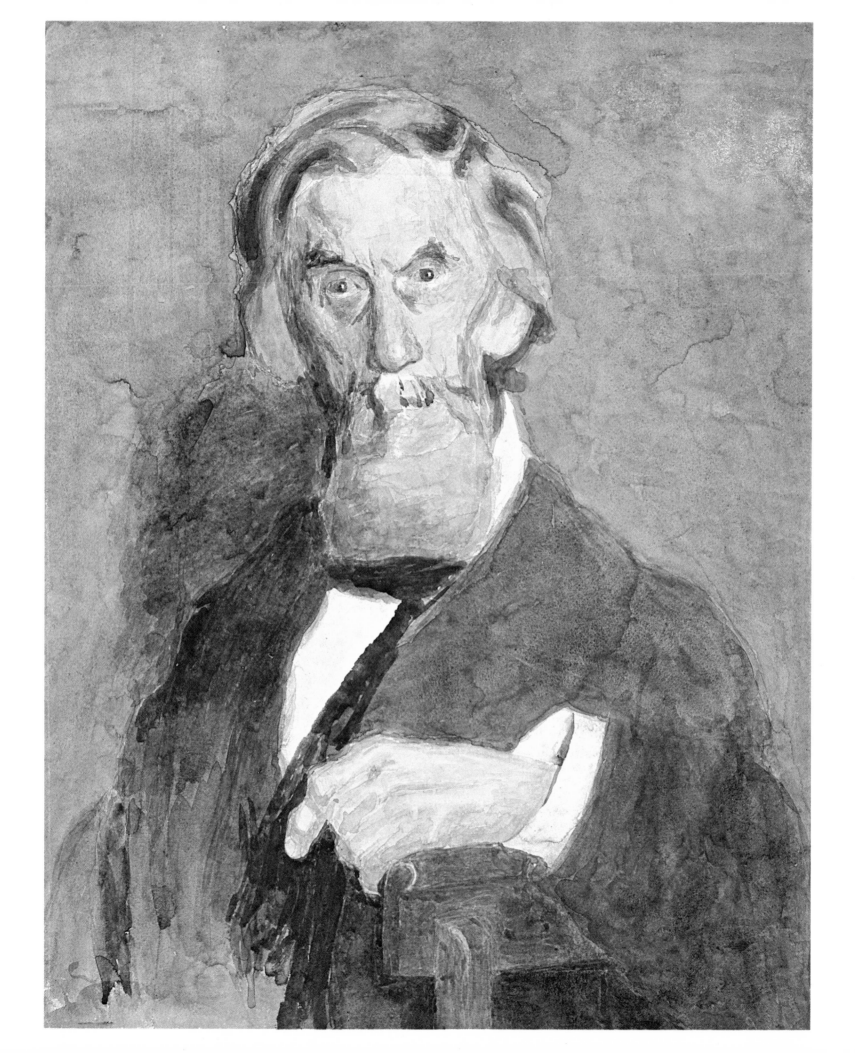

Edited by Donald Holden and Margit Malmstrom
Designed by James Craig and Robert Fillie
Graphic Coordination by Frank DeLuca
Set in 10 point Janson by York Typesetting Co., Inc.
Printed in Japan by Toppan Printing Company, Ltd.